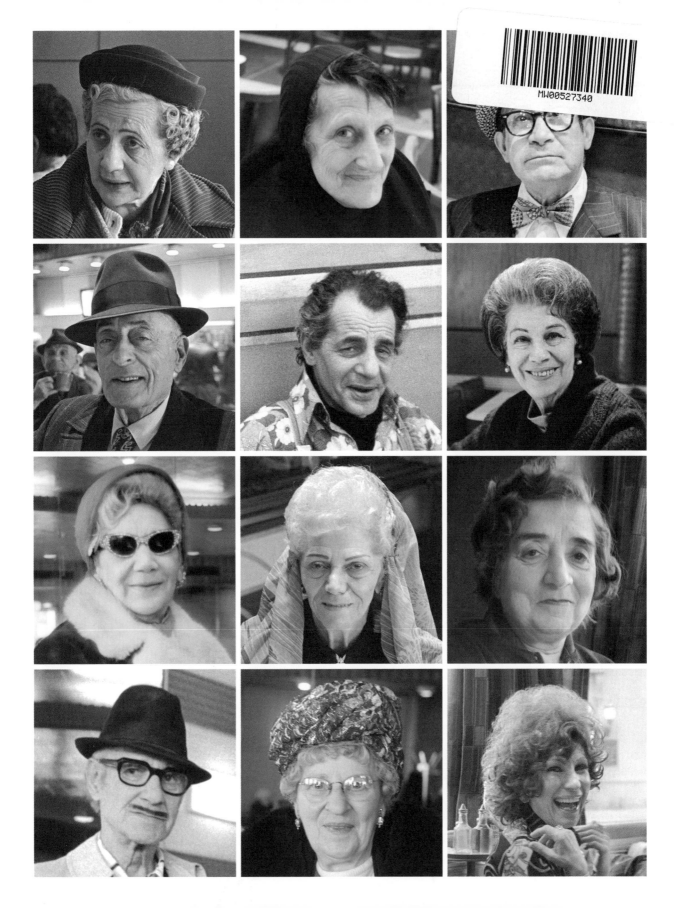

kibbitz & nosh

kibbitz & nosh

When We All Met at Dubrow's Cafeteria

Photographs by Marcia Bricker Halperin

Essays by Donald Margulies and Deborah Dash Moore

THREE HILLS

AN IMPRINT OF CORNELL UNIVERSITY PRESS

ITHACA AND LONDON

Epigraph: From "Footnote to Howl," from *Collected Poems, 1947-1997* by Allen Ginsberg. Copyright © 2006 by the Allen Ginsberg Trust. Used by permission of HarperCollins Publishers and The Wylie Agency LLC.

The John F. Mariani quotation is courtesy of John F. Mariani. "Dubrow's Cafeteria" by Isidore Century appeared in *Jewish Currents* (Spring 2011): 47. Reprinted by permission of *Jewish Currents*. The Robert Kelly quotation is reprinted by permission of Robert Kelly. The Uncle Slappy quotation was provided by George Tannenbaum.

First published 2023 by Cornell University Press

Printed in China

Design and composition by Chris Crochetière, BW&A Books, Inc.

Library of Congress Cataloging-in-Publication Data
Names: Halperin, Marcia Bricker photographer. | Moore, Deborah Dash, 1946- writer of added text. | Margulies, Donald, writer of added text.
Title: Kibbitz & nosh : when we all met at Dubrow's cafeteria / photographs by Marcia Bricker Halperin, essays by Deborah Dash Moore and Donald Margulies.
Other titles: Kibbitz and nosh
Description: Ithaca : Three Hills, an imprint of Cornell University Press, 2023. | Includes bibliographical references.
Identifiers: LCCN 2022015821 | ISBN 9781501766510 (hardcover)
Subjects: LCSH: Dubrow's Cafeteria—Pictorial works. | Cafeterias—New York (State)—New York—Pictorial works. | New York (N.Y.)—History—1951—-Pictorial works. | LCGFT: Photobooks. | Essays.
Classification: LCC F128.52 .H255 2023 | DDC 974.7/1022—dc23/eng/20220420
LC record available at https://lccn.loc.gov/2022015821

Holy the cafeterias filled with the millions!

—Allen Ginsberg

contents

kibbitz & nosh

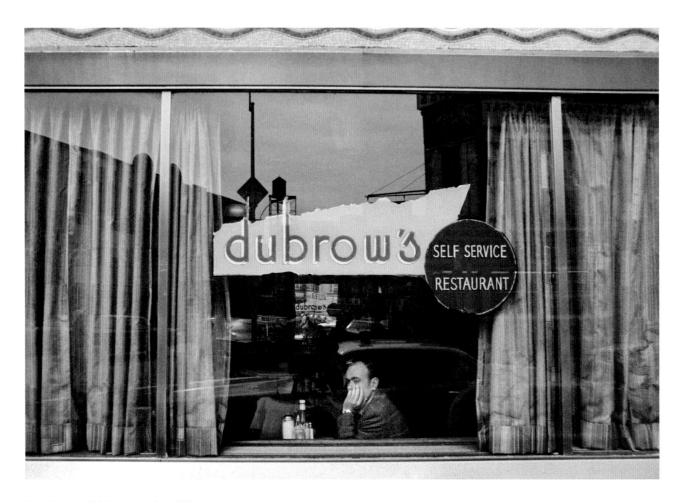

View through 16th Street window, 1975

Prologue

In 1974, after graduating as an art major from Brooklyn College, I was compiling a photography portfolio for an application to a master of fine arts program. I decided I would create a series by photographing store windows on Kings Highway, the thriving shopping thoroughfare that ran through my Flatbush neighborhood in Brooklyn. I was fascinated by the way in which you could capture so many layers through the complicated tones and textures of the glass surface.

The front windows of Dubrow's Cafeteria on Kings Highway and 16th Street were large and convex, set in a chrome and mosaic facade. The layers in my photographs included diners inside and those standing outside on the street. A long mirror in the interior reflected back yet additional layers. I was attempting to transcend reflection clichés in my work and create a sense of reverie, much like Eugène Atget did when he photographed the shops of Paris in the early twentieth century.

Dubrow's was an institution in Brooklyn long before I entered it, but I don't recall going out to eat there while growing up. For the Brickers, the occasional restaurant outing meant having something different, even exotic: Chinese food ordered from columns A, B, or C (lobster sauce), or Italian food—a veal cutlet parmigiana, perhaps. As I grew older, I would not have been pleased to have a date take me to Dubrow's, as it seemed to be a hangout for senior citizens. By

1

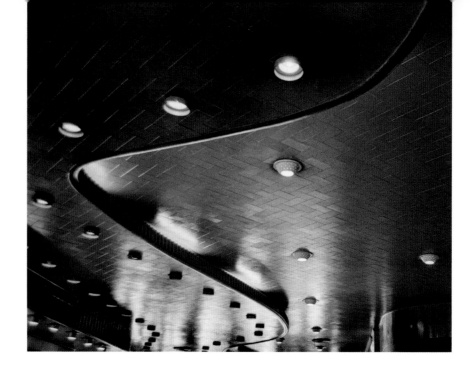

Dubrow's (detail), Kings Highway, 1976

the 1970s, I was much more impressed being taken by car to a twenty-four-hour diner with waiters in Sheepshead Bay, flipping through the selections on a table-side jukebox.

One day in February 1975, while photographing on "The Highway" (as Kings Highway was called), my ungloved, frozen fingers failed to flip the lever to advance the film in my Pentax Spotmatic camera. That's when I sought refuge through the revolving doors of Dubrow's Cafeteria. I took a ticket from Mr. Kornblum and found myself, for the first time, in that cavernous space gazing on amazing, unique faces bathed in light from the huge windows and reflected off the wall of mirrors. I was wonderstruck. It was the most idiosyncratic room I had ever seen. My eyes followed the sweeping, amoeba-shaped ceiling half an avenue to the back where it ended at a sparkling mosaic fountain. And it was right in the Flatbush neighborhood where I had grown up. "Go know!"—so went the expression I heard there in the late seventies, accompanied by a slight upward shrug and outstretched hands.

Photographing inside Dubrow's was not without its challenges. The photographs I created relied on a handheld 35mm camera. Some were made looking down into a boxy, 2 ¼ twin-lens reflex camera. I frequented Dubrow's on weekday mornings, evenings, and Sunday afternoons, when it was at its most crowded. Many of the initial photographs I made were candids, taken

surreptitiously, often including someone I was sharing a table with. The cafeteria management allowed me to sit for hours or to walk around and photograph the counter people, busboys, customers, and food displays. As I became a regular and people engaged me in conversation, the images shifted toward posed portraits. Many of my subjects smiled broadly into the lens in a relaxed way that a male photographer may not have been as likely to capture. Despite the canon of illustrious women photographers I was perceived as a novelty at that time. These photographs became collaborations with my subjects as I sought to stage them within the cafeteria environment and they put consideration into how they would perform for my camera.

Just as diverse as the décor was the lighting within the 45-by-150-foot cafeteria space. Some areas were flooded with natural light in the morning, and evening light was supplied by space-age inspired fixtures. This resulted in highly illuminated sections and pockets of deep shadows. My attempts at using a flash led to some comic situations. As recorded in a journal entry from 1975, after I took a photo using a flash, I overheard a couple at an adjacent table have a heated discussion about whether a light bulb was flickering out or the wife was imagining something. The use of a flash attracted unwanted attention and I was seeking to photograph impromptu interactions. Therefore, the majority of my photographs were made using available light.

In 1976, months after my first visit to the cafeteria, I wrote in my journal, "I was a celebrity at Dubrow's." It was a naive but true statement. When I walked into the legendary establishment, patrons waved and gestured for me to join their table. "Take my picture," they said, and plied me with Danish, cheesecake, or noodle kugel. I carried a large envelope stuffed with imperfect silver gelatin prints to give away, leftovers from hours spent printing in the darkroom. There was a steady supply of these prints as "burning and dodging" were irreversible manual techniques in the darkroom, unlike reversible photo editing in Photoshop.

The process resulting in a finished silver gelatin print began in my family's apartment under a heavy camp blanket. There, in the pitch dark and by feel, I popped open the film canister with a can opener and loaded the delicate strip of emulsion-covered plastic onto a reel, gently crimping the sprocket edges. Once the film had been placed in a light-tight canister I developed it in the kitchen sink, coordinating with my family's evening domesticities so as not to disrupt

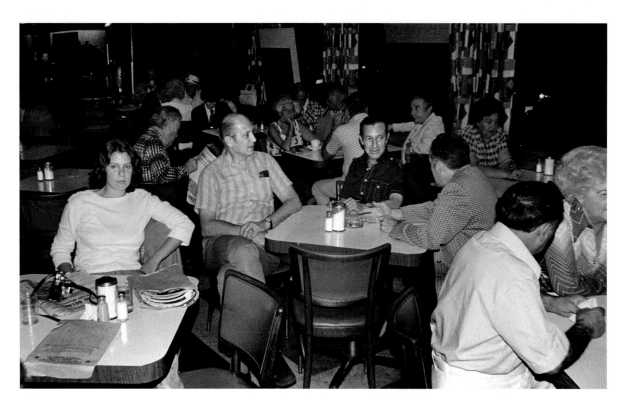

Author-photographer (*on left*) with print envelopes, Dubrow's, Kings Highway, 1977
(photographer unknown)

dishwashing. After a three-step chemical process I could finally open the canister
and hang the ghostly strip of negatives to dry from a clothespin on a line in the
bathroom.

The next day I cut the dry negatives into six frame strips, slid them into
glassine sleeves, and then rode over to the Brooklyn College photo lab on my
three-speed Royce Union bicycle to make thumbnail contact sheets and prints.
This was my technique from 1975 through 1977. In late 1977, when I was hired
by the CETA Artists Project of New York City, a federally funded program akin
to the WPA, I was able to move into my own apartment and set up a dedicated
darkroom. I became a working photographer, an opportunity that was transfor-
mative to my development as an artist.

I met amazing people at Dubrow's. Most were people I ordinarily would
never have had a conversation with over a cup of coffee—ex-vaudeville per-
formers, taxi drivers, Holocaust survivors, ex-prizefighters, and bookies. Women
named Gertrude, Rose, and Lillian all had sad love stories to tell and big hearts.

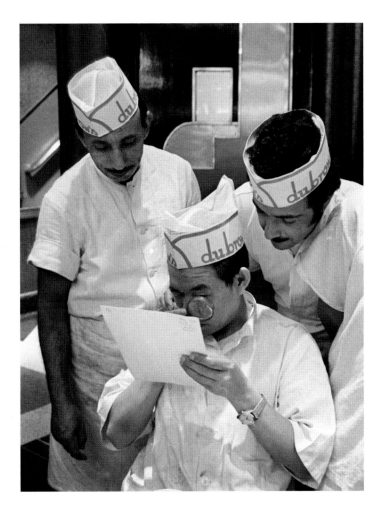

Busboys perusing contact sheets,
Dubrow's, Kings Highway, 1975

Conversation flowed freely at Dubrow's, and it was not unusual for patrons to walk around and greet friends at various tables as if they were at a large private party. For me it was also a "penny university." In my journal I noted discussions about the 1950s career of Eddie Fisher and guessing games about the age and profession of various habitués of the cafeteria. John F. Kennedy's campaign visit to Dubrow's in 1960 was still reflected on often, over fifteen years later. I was told that the staff of Dubrow's collected buckets of women's pointy slip-on shoes that were left behind by the throngs that filled Kings Highway that night—throngs that included my father.

 I believe I sensed it was a vanishing world on its last legs, and that impelled me to document it. I remember that, during the day, if someone wasn't nursing

a Danish and a twenty-five-cent cup of coffee for hours, the joke was, "Mind my seat, I have to go home to eat." On many visits the tables were empty, sans a painterly still life of condiment bottles and jars in the morning light. I also perceived cafeterias as places that embodied a secular Jewish culture, something that was of great interest to me. In 1977 I attended a lecture by Isaac Bashevis Singer, who was billed as an "Outstanding Anglo-Yiddish" author, at the Brooklyn Jewish Center on Eastern Parkway in Crown Heights. I adored his short stories, many of which were set in cafeterias, and I regret never finding the nerve that day to tell him about my own *cafeterianiks*.

When the Dubrow's on Kings Highway closed in 1978 I continued to photograph other last witnesses to these vanishing special places at the Dubrow's in the Manhattan Garment District, the Horn & Hardart on 57th Street, and the Paradise Cafeteria on 23rd Street and Sixth Avenue. I found the clientele at the Manhattan Dubrow's to be mostly garment industry workers and transient midtown shoppers. Although that Dubrow's location had appealing futuristic décor features and a large mural right out of a Hollywood set, complete with fashion models and Greek goddesses, it never became a community space for me until the final closing hours in 1985. On that night a small group gathered for an impromptu farewell party where we quietly pocketed trays and spoons and with commensality ate our last piece of creamy nesselrode pie.

Dubrow's was the type of place where the genders were referred to as guys and dolls, and I was enamored of that Runyonesque atmosphere. Gossip, lipstick, powder puffs, cigars, kerchiefs, fedoras, leopard pattern coats—all the cafeteria denizens' accoutrements for dining on gefilte fish, kasha varnishkes, rice pudding, or blintzes. Perhaps the splendid and opulent visual elements of the interior served to counter the isolation, depression, and, sometimes, the poverty of its older customers, who came up through the anxieties of the Depression and World War II. Older Ashkenazic Jews, who liked to tell me nostalgic stories of hardship, could eat reimagined Eastern European Jewish foods at cafeterias. The noodle kugel at Dubrow's was chock full of dairy—flaunting cottage cheese, cream cheese, sour cream, milk, and butter—and was topped with a sweet red fruit sauce. This was not an Old World kugel but a showcase of New World abundance. The pastoral mural, with its images of bountifulness on a baroque scale, and the plastic flowers that adorned displays of food choices may have served

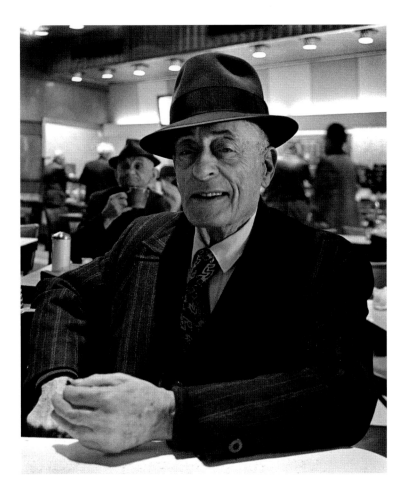

Mike, vaudeville tenor,
Dubrow's, Kings Highway,
1975

to counter, for a time, these feelings as well. The civil rights of smokers were well-supported at Dubrow's, from the cigarette machine by the entryway to the ubiquitous table ashtrays. Mornings appeared more atmospheric as light filtered through a cloud of cigarette smoke that hung over the room. In more than one of my photographs a stray rectangular line on the edge of the frame turned out not to be a deep scratch on the negative but a cigar edging into the picture. I clipped and saved a 1996 *New York Times* opinion piece in which the playwright Wendy Wasserstein lamented the presence of big box stores and fast food restaurants throughout New York City. She ended her short essay by writing, "You would never meet Nathan Detroit at a Starbucks counter."[1]

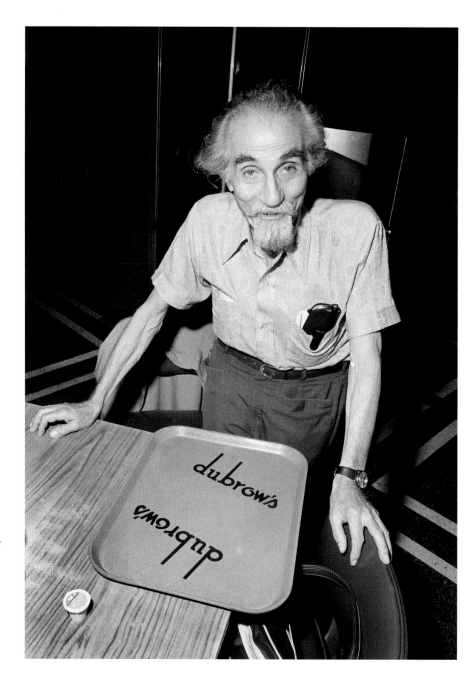

Leib Lensky, a character actor who played the ticket man in the 1984 PBS production *The Cafeteria*, based on a short story by Isaac Bashevis Singer. Closing night, Dubrow's, Garment District, 1985

After retiring from a thirty-five-year career in education I began a deep dive into my contact sheets and began making scans, including negatives that had never been printed. I uncovered images I had totally forgotten, and tiny details in others emerged into full stories. The photographs in this book have been lightly organized into two sections. The first body of work, "Where It's Happening, Come to the Highway," was taken in and around the Dubrow's on Kings Highway. The photographs in the second part of the book were taken at various times of day in the Dubrow's on Seventh Avenue in the Garment District, "the epicenter of the schmata business."[2] Searches and Google alerts for Dubrow's Cafeteria over many years have led me to memories in prose and poems, a few interspersed here, that I feel help complete the story. Over the years I had continued researching cafeterias, meeting and interviewing Dubrow family members, and finding people with connections to the workers and people in my photographs. They contacted me through social media, and whenever a photograph was published there was a flurry of emails: people claiming to have seen their Aunt Rose or Uncle Nick staring back at them from a photo. My friend Nancy, a retired principal, was thrilled to find her father in a photo from 1977, a Chinese immigrant who, despite being illiterate in English, rose to the position of night manager at the Garment District location. She remembers him leaving small presents on her pillow that wholesalers gave him for her and her five siblings.

Whenever I've traveled, I check to see if there is a cafeteria still in existence in that city. Over the years, I've dined at the Zodiak Cafeteria in Warsaw, the Concord Cafeteria in Miami Beach, Clifton's in Los Angeles, the Piccadilly in Savannah, and a Horn & Hardart Automat in Philadelphia, among others. All shuttered now. Sometimes I dream about traveling someplace and discovering a uniquely designed cafeteria, created by an immigrant, that is a gathering place for the last remnants of a working-class social and cultural world.

Notes

1. Wendy Wasserstein, "When Superstores Were Truly Super," *New York Times*, October 27, 1996.

2. George Tannenbaum, "About Food, Uncle Slappy Talks," Ad Aged blog, November 26, 2015.

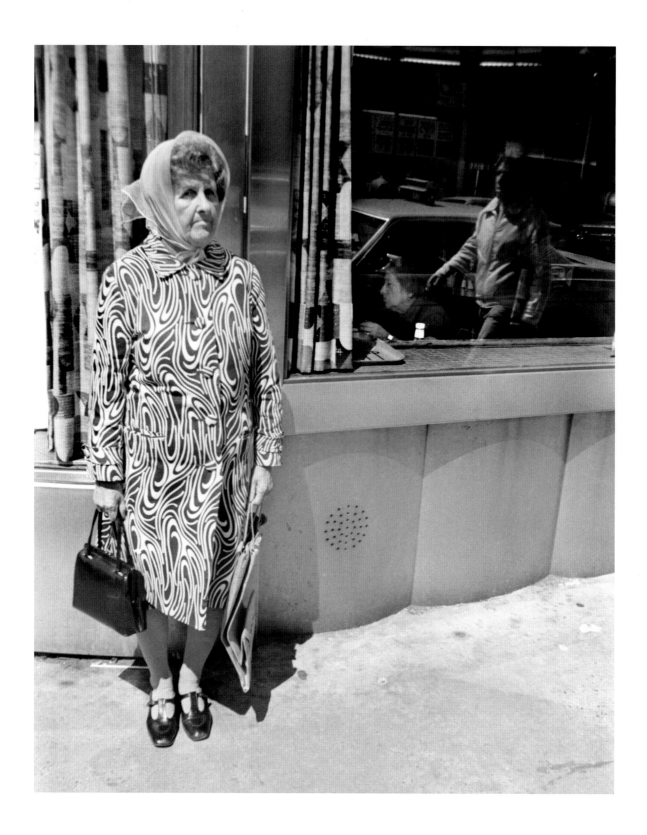

Sundays at Dubrow's, or
Remembrance of Creamed Spinach Past

DONALD MARGULIES

In the Brooklyn of my baby-boomer youth, two restaurants were at the top of a boy's list of magical places. One was Lundy's, the stucco seafood pavilion occupying a whole block on Emmons Avenue right across from Sheepshead Bay. Extravagant by my family's standards, Lundy's—famous for its multicourse, seemingly endless Shore Dinner (consisting of biscuits, warm from the oven; clam bisque with hexagonal oyster crackers; steamers; lobster with a baked potato on the side; and apple pie à la Breyer's vanilla ice cream for dessert)—was reserved for special occasions like birthdays and graduations.

The other destination, the far more *heimish* Dubrow's, with its gleaming forest-green facade and neon letters spelling out CAFETERIA, held a fascination all its own.

Dubrow's, on Kings Highway, was where we'd get something to eat when my mother schlepped my brother and me shopping for school clothes, or before a double-feature at one of the two air-cooled Century theaters: the Kingsway on the corner of Coney Island Avenue or the Avalon, a block away from Dubrow's. A pre-movie matinee lunch might include kasha varnishkes, cheese blintzes with applesauce and sour cream, and creamed spinach. (I loved their creamed spinach. I must have been an unusual boy: what kind of kid loves creamed spinach?) Sometimes, depending on what sort of mood my mercurial father was in, we'd

11

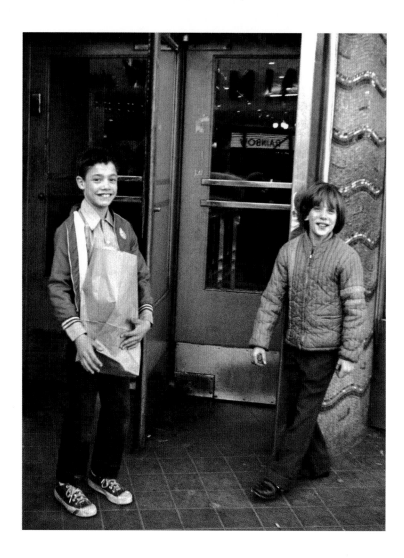

Boys outside Dubrow's,
Kings Highway, 1975

return, after the movie, for a treat of rice pudding or lemon meringue or Boston cream pie.

Those family outings typically took place on Sundays. Sunday was my father's one day off from working in the wallpaper department of Pintchik Paints, another Brooklyn landmark of sorts, known to all who entered the borough from across the Manhattan Bridge for its loud painted signage splashed across several buildings on Bergen Street and Flatbush Avenue.

One Sunday, while we were lunching at Dubrow's, a hurricane hit Brooklyn. The thunder and lightning were dramatic; a torrential downpour quickly flooded

the place. We were stranded, like in a *Twilight Zone* episode, a throng of refugees from the storm. While we rode out the rain, I remember watching with fascination as each rotation of the revolving doors sent tidal waves cascading across the patterned terrazzo floor.

My family lived, in Brooklyn-speak, on Ocean between X and Y in Sheepshead Bay until 1964, when we became the first occupants of our apartment in Trump Village in Coney Island. We moved again, in 1973, to Avenue R between 13th and 14th, a few blocks away from the Kings Highway station on the Brighton Line. Under the station was the Te-Amo newsstand soda fountain known for its chocolate egg creams; right next door was Dubrow's.

Marcia lived on Avenue R, too. (We recently discovered we were, for a brief time in the mid-1970s, neighbors.) But Marcia never set foot into Dubrow's, she told me, until she was in her twenties. What she encountered was a teeming microcosm of Brooklyn life, an environment that inspired the rich images memorialized in this book.

When you passed through the revolving doors from bustling Kings Highway, you'd be struck by the change in acoustics. The mechanical rumble of the elevated D train and the din of traffic would give way to the interior clamor of cutlery and conversation, of dirty dishes being dumped in plastic tubs by busboys in white. You'd glimpse old men perusing racing forms over lunch, yentas having coffee and Danish, couples eating in silence, and harried young parents with restless kids running around.

The first person to greet you, the closest thing they had to a maître d', was an elderly gentleman, always dressed in jacket and tie, planted on a stool and handing checks to arriving diners. The man was a Dubrow's fixture; more likely there was a succession of lookalike old men, but I prefer to imagine he was the lone sentry for decades. The sign atop the check-dispensing machine—"Minimum Check 25c / No Blank Checks"—was a warning to freeloaders who might hope to while away the hours without buying so much as a cup of coffee. On the check were printed columns of numbers—prices of courses of food—which would be hole-punched by servers behind the counter and tallied by the cashier at the end of your visit.

At the far end of the cavernous room bustling with humanity, drawing the eye to the far wall, was a mosaic tile spray pattern against a cobalt blue background

above a self-serve water fountain. There was something fabulous about that Art Deco decoration, better suited, perhaps, to a Busby Berkeley extravaganza than to a Brooklyn cafeteria. It lent the back area, by the kitchen and bathrooms, a splash of glamour. Marcia captures that incongruity in her portrait of a zoftig, dark-haired, middle-aged woman posing proudly in front of it, like a chorus girl, hand on hip, knee bent coquettishly. The image is deceptively poignant, for the photographer (as seen throughout her work from this period) imbues her subject with a palpable sense of dignity.

When I look at Marcia's photographs from the seventies, the Dubrow's of my Brooklyn boyhood in the late fifties and sixties comes to life. I know this place and these people, frozen in time. This is the cast of characters that populated my world. They are the neighbors, shopkeepers, and relatives I knew when I was growing up. It is not just their faces that come alive, but their voices, too: the rhythm of their language, the music of Jewish Brooklynese.

The etch-faced woman in the zebra-swirl coat standing outside the eatery in the afternoon sun reminds me of my grandmother. Her stylish coat and freshly coiffed, lacquered hair, under a kerchief, capture the vanity of an older widow still invested in her appearance. I can hear my Nanny's rationale: "You never know, darling. You might run into someone you know."

Another old woman in a knitted cap, seated at a window table, looks out at the street. Is she people-watching, or has she turned, having sensed the photographer capturing her with her camera? The happy visual accident of the woman's Fair Isle patterned sweater complementing the decoration on the Checker cab reflected in the window makes the picture especially striking. Layers of images, like double and triple exposures seen through or reflected on glass, dissolve into one another; translucent, ghost-like figures seem more like figments of memory than corporeal fellow diners. Mid-argument, a man wearing glasses points his finger emphatically at his burly lunch companion. Behind them one discerns the iconic silhouette of a bottle of Heinz ketchup.

A different older woman, centered in the lower foreground, fixes her lipstick while looking at a compact. Her mustachioed husband, accustomed to this after-dinner ritual, stands behind her while donning his raincoat. His eye contact, the equivalent of his breaking the fourth wall, makes the photographer complicit in the narrative.

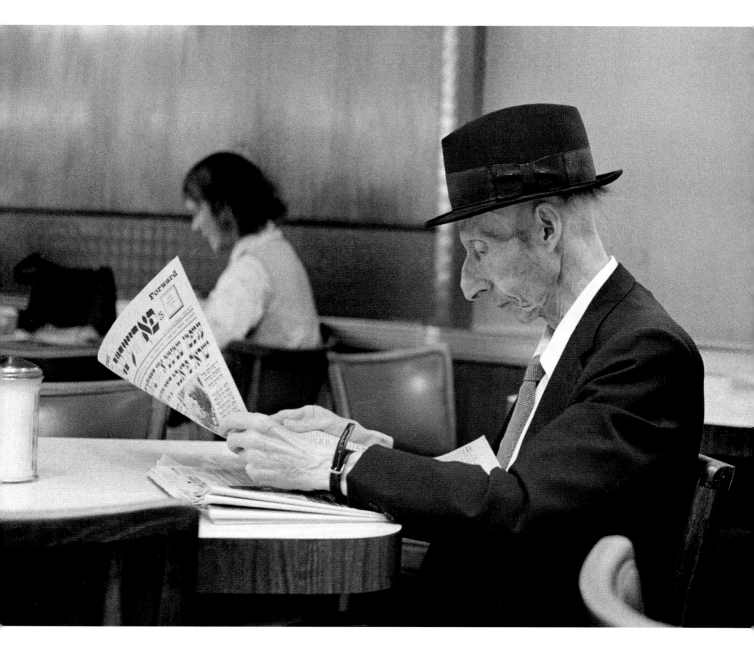

Man reading Yiddish newspaper, the *Forverts*,
Dubrow's, Kings Highway, 1975

Like the best of street photographers, Marcia is essentially a storyteller. Her portraits are compassionate, clear-eyed, and unsentimental.

Her images often capture naked, Edward Hopper–like existential moments of men and women, sometimes together, sometimes dining alone, often lost in space. Perhaps they are escaping loneliness by taking a solitary meal in public or nursing a cup of coffee, one suspects, for hours.

Many of these cafeteria subjects evoke Impressionist Parisiennes—one woman is reminiscent of, say, Degas's *Absinthe Drinker*. Her elbows are on the table and her chin is resting on her hands. She is bathed in overhead light, a mink stole draped over her shoulders as if spilling down from her glowing blonde hair. There is a forlorn, perhaps expectant quality about her pose. Has she been stood up? Is her husband or companion running late or have they gone to fetch food— or has she come here alone simply to watch and to be among people?

An older woman, deep in thought, white hair, white tabletop, wears a hand-crocheted hat that seems to pour from the undulating foliage of the mural directly behind her: bare-shouldered maidens and muscular men, like extras in a biblical epic commissioned by the WPA, cornucopia atop their heads overflowing with the fruits of their bounty. What are we to make of the grandeur of that imagery in a cafeteria on Kings Highway? The juxtaposition of the woman and the fecund harvesters is almost cruel. There is something terribly human in the performative aspect of working- and middle-class Brooklynites dressing up to go out to eat and sit alongside mosaic fountains and exotic murals.

That faux glamour is in stark contrast to the practicalities of Dubrow's. There was no waiter service, remember, so these diners would first stake out a table; leave a coat, newspaper, or shopping bag behind to claim their place; then grab a tray and line up to get their own food. They'd choose their meal from prepared portions or place orders for custom-made plates before returning to their table to enjoy it.

In one of my favorite portraits, an elderly Jewish man engages in a morning ritual: reading the Yiddish newspaper the *Forverts* (Forward) before unfolding the *New York Times*. His Old World profile, like that of an ancient rebbe, calls to mind Roman Vishniac's Eastern-European ghetto dwellers who themselves evoke a blighted, faraway past.

Marcia's vanished cafeteria photographs date from the late seventies, now more than forty years ago, but they seem even older. They are graphic evidence, documentary proof, of a lost time and a lost culture. The generation so familiar to me, and so poignantly depicted in these images, has died out, and landmarks like Dubrow's have been shuttered. The hallowed cafeteria closed its revolving doors for the last time in 1978, the same year my mother died, just a few blocks away.

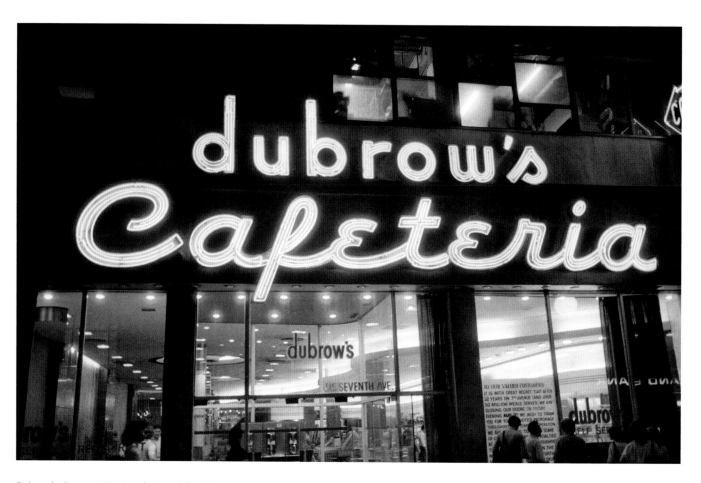

Dubrow's, Garment District, closing night, 1985

See You at Dubrow's

DEBORAH DASH MOORE

Right after Thanksgiving on November 27, 1937, an unusual musical opened at the small Union Theater. *Pins and Needles* featured members of the International Ladies' Garment Workers' Union performing skits that commented on current events from a left-wing political perspective. Its opening number, "Sing Me a Song with Social Significance," established the theme: no romance without commitment . . . to proper politics. The revue gleefully skewered dictators, fascists, and capitalists along with other enemies of the working class. Word of mouth attracted crowds and soon the union show moved to a regular theater schedule, updating the skits year by year, in response to the late 1930s' rapidly shifting geopolitics.

One of the new songs, "Mene, Mene, Tekel," skewered dictators and their ways by riffing off the biblical book of Daniel where this mysterious phrase appeared on the palace wall. A female Christian preacher belted out an attack on the "Jerusalem-Babylon Axis." King Belshazzar got her point, for it was "shining out just like a cafeteria sign."[1]

Neon was a popular mode of signage on cafeterias in New York City. That a message broadcasting the downfall for dictators shone like a cafeteria sign signaled the ubiquity of cafeterias in New York City by the late 1930s and, perhaps less obviously, their Jewishness.

The Great Depression spurred the growth of cafeterias. These self-service restaurants offered patrons a seat at a table in a well-lit, heated room for the cost of a cup of coffee. They could be found in downtown and midtown Manhattan where they catered to white-collar workers on lunch or coffee breaks. They also flourished in working-class residential neighborhoods in the Bronx and Brooklyn. Jewish immigrants patronized them throughout the day and night in the Brownsville section of Brooklyn. Cafeterias like Hoffman's on Pitkin Avenue, Brownsville's main shopping street, attracted regulars who used them as places to meet friends, escape cold weather, go on dates, and talk politics and unionism—sometimes all at once. The literary critic Irving Howe, who grew up in the Bronx in the 1920s, recalled frequenting "cafeterias in which the older comrades, those who had jobs or were on WPA, bought coffee while the rest of us filled the chairs."[2] Although Jews were not the only ones to patronize cafeterias, they preferred them as inexpensive places to hang out to bars, which often attracted an Irish immigrant and working-class clientele. By the 1930s, cafeterias were part of the fabric of Jewish neighborhood life in New York City, a welcome alternative for socializing to cramped apartments, street corners, or candy stores.

Cafeterias' social appeal as what sociologists call a "third space" represented an unanticipated evolution for these purveyors of food and drink. Unlike taverns, bars, coffee shops, or cafes, cafeterias in New York City began as a fast-food option for Wall Street stockbrokers at the end of the nineteenth century. In the first cafeterias, men grabbed their food, ate it standing up at tall tables, bussed their plates, and then reported what they ate and paid for their meal. As cafeterias grew in popularity during the early twentieth century, they ceased to be "conscience joints," relying on an individual's honesty in paying for his meal. But they remained "grab joints" even as they developed into places that served more people with minimal staff.

Cafeterias spread around the country, far from Wall Street. They often could be found next to train stations and bus terminals or other spots where large numbers of people congregated. Schools and hospitals adopted the cafeteria format. And commercial cafeterias multiplied. Unlike restaurants that employed waiters, cafeterias retained the self-service concept. Once trays were introduced, customers could carry anything from a snack to a full meal over to a table.[3] By the 1950s, almost every main street in cities across the United States

had some form of cafeteria. But nowhere were the streets as filled with them as in New York City, where the many midtown office workers and new working women needed satisfying, inexpensive meals served quickly and in respectable surroundings.

The flexibility of cafeteria menus, layouts, and locales encouraged diversity. Some cafeterias appealed to white-collar workers; others attracted working-class women and men. Still others served taxi and delivery truck drivers.[4] The cafeteria's appeal overrode class and occupational differences.

Perhaps the most famous self-service restaurant was Horn & Hardart's Automat, brought from Philadelphia to New York City's Times Square in 1912. "A gigantic, coin-operated vending machine with row upon row of windowed compartments, resembling glass-fronted post office boxes, housed dozens of menu items," as Christopher Klein describes the scene. "After window shopping, customers could drop a nickel into a coin slot, turn a knob, lift up the door and help themselves to their food."[5] Initially offering a limited menu of buns, beans, fish cakes, and coffee for a nickel an item, the types of food and range of cost points grew in the 1930s. Seen as a symbol of life in the city, automats reached their heyday in the 1940s and 1950s, when over fifty across Brooklyn, the Bronx, Manhattan, and Queens served more than 350,000 customers per day.[6] Manhattan alone had twenty-seven automats in 1970.[7] Their omnipresence contributed to a sense that automats exemplified New York's fast pace.

Shrinking lunch hours and a desire for inexpensive meals spurred cafeterias' growing appeal. As they spread to new neighborhoods, cafeterias targeted local folks of different ethnic groups as potential clientele. Although many workers brought their lunches from home and ate at their workplace, the possibility of having a cheap meal at a nearby cafeteria in only twenty minutes offered a tempting alternative for workers of all socioeconomic levels.[8] New York Jews particularly embraced cafeterias, less as a fast-food option than as a place to sit and schmooze.

—————

Fifty years of immigration by Eastern European Jews transformed New Yorkers' foodways. By 1920, approximately 1.6 million Jews lived in New York City, concentrated in Brooklyn, Manhattan, and the Bronx. The majority were either

immigrants or the children of immigrants, the second generation. Jews constituted the city's largest single ethnic group, although Catholics were the largest religious group, albeit divided by ethnicity.[9] Many Jews did not strictly observe the laws of kashrut, but enough of them followed the basic kosher principles of separating meat and milk to shape the city's industrial food production. New York Jews' desire for kosher meat stimulated the expansion of freshly slaughtered meat in the city. In addition, the prominence of chicken in the diet of New York Jews transformed the production of this inexpensive food. Trains regularly carried boxcars of live chickens into the city to be slaughtered in hundreds of local kosher butcher shops.[10] By 1934 approximately twelve thousand kosher food processors and dealers, a two-hundred-million-dollar business, accommodated Jewish foodways.[11] Jews' appetite for fresh fish (but not shellfish) sustained a booming fish market. Jewish bakeries, neighborhood stores to wholesale factories, catered to the city's taste for breads, offering challah, pumpernickel, rye bread, and bagels.[12] Typically, Jewish merchants featured either meat or dairy products, even if a store was not strictly kosher. In the years before World War II Jewish foodways gradually became integral to the foodways of the city.

As Jews left the immigrant Lower East Side in the early decades of the twentieth century for new apartments in Brooklyn, the Bronx, and northern Manhattan, they brought their foodways with them. Increasing numbers of delicatessens and appetizing stores (the term used for dairy stores) dotted Jewish neighborhoods throughout the city. The former sold cured meats while the latter purveyed prepared fish, salads, and dairy products. Both exemplified distinctive Jewish foodways. In fact, delis became such iconic New York Jewish institutions that their presence often identified a Jewish neighborhood more clearly even than that of a synagogue. Second-generation Jews enjoyed more socioeconomic security than their immigrant parents. The prosperity that enabled residential dispersion also enticed Jews to eat out more often and in an expanding range of venues. In the many delicatessens and appetizing stores customers purchased prepared food and brought it home to be consumed around the kitchen table.

Immigrant Jews enjoyed restaurant food service only on special occasions; by contrast, second generation Jews "ate out" in varied settings. Friends, couples, and families would catch a bite or dine out in conjunction with going to the

movies, a concert, or the theater. The popularity of eating out also contributed to a modification of Jewish observance of kosher laws. Many New York Jews practiced one form of kosher norms at home and another, far less strict version when they "ate out."

In the 1920s Jewish cafeterias entered the mix of New York City dine-in establishments. They differed from delis and appetizing stores, restaurants, and cafes in a number of ways. Unlike delis and appetizing stores, cafeterias always provided tables and chairs. Food was expected to be consumed in its space (though it was also possible to buy food for takeout). Most Jewish cafeterias did not follow strict kosher practices of separating meat and milk, with two sets of dishes, silverware, and pots and pans, and supervision by an Orthodox Jew. One kitchen produced both types of food. It was up to each individual to decide whether or not to buy only one or both categories. Unlike restaurants or cafes, cafeterias did not offer table service. There were no waiters to tip for bringing the food and drink. Instead, customers assessed their food options from a counter array, chose what they wanted, and found a table, which frequently had to be shared. Customers could eat as little (say, a Danish) or as much (a full roast chicken dinner with two sides, along with soup, salad, and dessert) as they wanted. Most of the food was prepared in the kitchen and kept warm or cold, to be portioned for each customer. Sandwiches were made on the spot. Meats and cheeses were freshly sliced per a customer's request. Customers could also sit at a table for as long as they wished.

This opportunity to linger contributed to a cafeteria's distinctive atmosphere. Most cafeterias attracted regulars, along with casual patrons. The former usually differed depending on the time of day. Mornings drew people on their way to work or school as well as older clusters of retired men and women who met friends for breakfast and conversation. They rarely overlapped with the midday crowd of workers on their lunch break. Afternoons might find women gathering for rest and refreshment as part of a shopping trip, mothers with small children in tow, or teenagers hanging out. The evening regulars often included sports fans and young men and women on dates after a movie. Less savory characters also became regulars, commandeering a table or two where they conducted business, such as bookmaking.

In 1929, however, Benjamin Dubrow was not thinking about cafeterias. Instead, he was planning to open a full-service restaurant in Brooklyn, complete with waiters. At the time, construction was booming in Brownsville, a majority Jewish working-class neighborhood. A huge new Loew's movie theater was going up on Pitkin Avenue, with seats for almost three thousand. Occupying an entire city block, it promised a total experience of fantasy, romance, and excitement in an opulent space.[13] Dubrow chose a spot for his restaurant in middle-class Crown Heights at the intersection of Eastern Parkway and Utica Avenue. The location possessed the possibility of attracting immigrant Jews from neighboring Brownsville as well as a local middle-class clientele. Dubrow lived in an apartment on tree-lined Eastern Parkway and recognized its attractions to ambitious, upwardly mobile Jews like himself. Designed by Frederick Law Olmstead in the nineteenth century as an elegant boulevard, Eastern Parkway hosted stately six- to twelve-story apartment houses, many constructed by Jewish builders. The restaurant's location in a two-story taxpayer, as such buildings were labeled, at 1110 Eastern Parkway was well situated by an express subway station on the newly extended IRT line. Dubrow leased the ground floor; offices were upstairs.

Dubrow's, Eastern Parkway, c. 1950 (Brian Merlis/oldNYC photos.com)

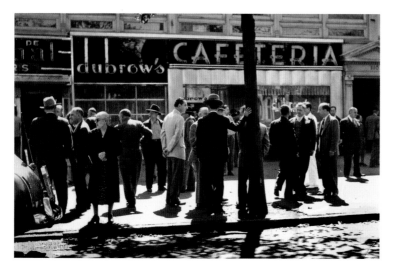

Across the street, the imposing East New York Savings bank signaled the intersection's respectability. A few blocks to the west on Eastern Parkway stood the magnificent Brooklyn Jewish Center, a million-dollar synagogue center with its own swimming pool completed in 1920. The Brooklyn Jewish Center boldly announced the arrival of affluent Jews in the neighborhood.

The area radiated industrious prosperity. Like the Loew's cinema, Dubrow's Pure Food restaurant, the name under which it was

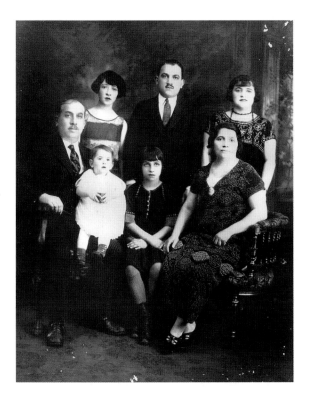

Dubrow family portrait, c. 1929. Front row from left: Benjamin Dubrow, Ruth (on lap), Sylvia, Rose Dubrow (wife); back row from left: Lila, George, Minnie (courtesy of Eve Lyons)

incorporated, was designed to induce locals to enjoy themselves. The restaurant's sign featured the "dubrow's" name in strikingly high-art moderne style. Its elegant lowercase letters launched balanced back-to-back d's and b's like a pair of chairs buttressed by serifs at attention. On the building's facade, curved metal curtains framed the plate glass windows that enclosed the entrance. Inside, a mural featuring a flamingo and its companions adorned one wall. Dubrow hired nine waiters and enough cooks to run an efficient eatery.

Benjamin Dubrow was an experienced restaurateur. He had immigrated to New York from Belarus in 1914, aged thirty-six, along with his pregnant wife, Rose, and three children (two more would be born in New York). He soon opened a delicatessen in upper Manhattan. Subsequently he operated several small restaurants. The shift to Dubrow's on Eastern Parkway reflected his own move to booming Brooklyn. The borough added half a million residents in the 1920's, 50 percent of them Jews. By 1930, Brooklyn's Jewish population surpassed that of Manhattan as the borough with the largest number of Jewish residents.[14] But starting a new restaurant also represented a chance to go into business with his only son, George. Benjamin Dubrow sold his Manhattan place and invested in their eponymous restaurant.[15]

Then the stock market crashed. Few New York Jews owned stocks, so the crash did not immediately affect them. But the subsequent failure of the Jewish-owned Bank of the United States in December 1930 "signaled the beginning of the Great Depression" and New Yorkers' disposable income disappeared.[16] As unemployment spread in New York, the impact of the Depression registered throughout the city. During those dark days of 1930, even white-collar workers had no money to spend on a sit-down meal in a restaurant. Dubrow realized that if he was to save his investment, he needed to transform it into a cafeteria. With

a cafeteria he did not need waiters and he could serve more customers at more modest prices.

In January 1931 Dubrow dismissed the wait staff. Then he turned to the cooks and countermen's union to hire new help. But the union agreed only on the condition that he would also hire waiters from its sister union. Dubrow refused. Members from both unions picketed the business, standing outside with signs. Dubrow then went to the courts and was granted a temporary injunction to stop the picketers. Frustrated, the cooks and countermen declared they were on strike. But 1931 was not a propitious time for unions. The case of *Dubrow Pure Food v. Glazel* ended badly for the waiters' union. In 1932 the court granted a permanent injunction against picketing, finding it "unwarranted."[17]

The court initially ruled against the waiters on the grounds that they didn't have the right to picket because the cafeteria was a new business model that didn't require their services. Since for picketing to be lawful the picketers must have standing against the business they are picketing, the waiters lost that relationship with Dubrow's when it became a cafeteria. The permanent injunction against cooks and countermen prevented them from picketing to save jobs, because the court deemed that an invalid reason to picket.[18] It was not an auspicious beginning.

Nonetheless, Dubrow's Cafeteria succeeded during the difficult Depression years. It attracted Jews and others living in Crown Heights, Flatbush, and Brownsville. Although Jews suffered like all New Yorkers, reliance on self-employment buffered some of the worst effects of the economic crisis. "The employment patterns of New York Jews helped them survive the economic crisis in a comparatively fortunate position," writes historian Beth Wenger. Jews certainly did not escape the hardships of the Depression, including unemployment, downward social mobility, dislocation, and "persistent economic insecurity." Yet, comparatively and collectively, they weathered these difficult years better than other more vulnerable groups.[19]

A mix of businessmen and lawyers, accountants and public-school teachers occupied Dubrow's tables depending on the time of day during these challenging years. Men and women, young and middle-aged, housewives and high schoolers savored the food choices available, picking what they liked and could afford, even if it was only a cup of coffee for a nickel. On Sundays a line of people queued

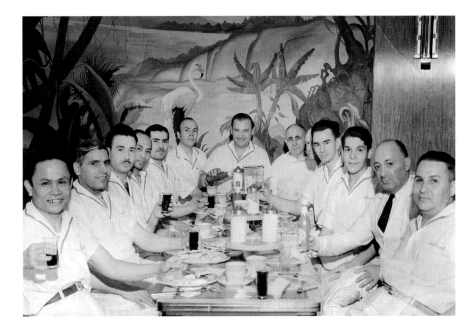

Dubrow's staff, Eastern Parkway c. 1940, second from right, George Dubrow; fourth from right, Henry Jablonski (courtesy of family of Henry Jablonski)

up at the entrance. In a nod to its Jewish identity, Dubrow closed the cafeteria on a few major Jewish holidays, a slow time for customers. On Yom Kippur, the Day of Atonement, when Jews fasted and abstained from work, one counterman recalled, "We had to clean the whole store, top to bottom. It was the only time we ever closed."[20]

The cafeteria's talented cooks and bakers produced popular Jewish delicacies at reasonable prices. One of the countermen recounted that the "food was made like banquet styles but for a poorer clientele, without all the fancy trimmings and extra expense." He noted the labor that produced the finished dishes. The cooks dealt with large wholesale orders. "At Dubrow's, everything came in," he explained, "when you ordered"—"a whole half a cow" might arrive from a butcher, "or fish, a whole halibut, a hundred-pound halibut." As a result, Dubrow's employed chefs and bakers along with cooks who knew how to butcher meat and filet fish. "In those days, everything was more or less made fresh," recalled Henry Jablonski, who worked at the Eastern Parkway and, later, Kings Highway Dubrow's. "The potatoes were peeled fresh, even the orange juice, we used to squeeze oranges."[21]

Staying open late at night, Dubrow's became a favorite hangout for bookies and Brownsville racketeers, sporting fans and politicians. The cafeteria attracted members of Murder, Inc., the violent Jewish gang that dominated Brownsville

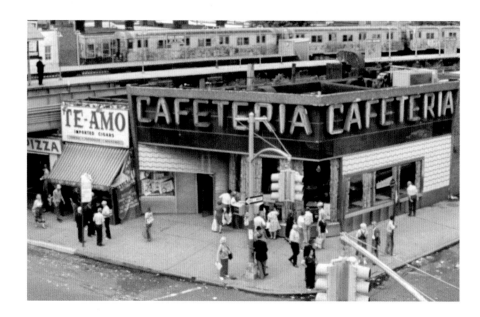

and controlled sections of Brooklyn, during its heyday in the 1930s. These Jewish gangsters like Abe "Jew Murphy" Babchick were regulars who frequented the cafeteria night after night. Police knew where to find them, but those who paid protection money had nothing to fear.[22] Dubrow's also drew frolickers following the roller rink races and boxing matches at the Eastern Parkway Arena. Only three blocks away, the cafeteria profited from the crowds enjoying these sporting events as well as fans from baseball games at Ebbetts Field. Even after Prohibition ended, Dubrow's eschewed alcohol. It did not serve liquor. Yet despite its inauspicious beginnings, Dubrow's not only survived the Depression but flourished.

In 1939, eager to build on his unlikely success during the Depression, Dubrow opened another cafeteria at 1521 Kings Highway, on the corner of 16th Street, with a twenty-one-year lease. Optimistically, he spent over $100,000 on improvements.[23] Like the Eastern Parkway location, the Kings Highway Dubrow's stood across from an express stop, in this case on the Brighton line of the old BMT system. A twenty-minute ride from the Kings Highway station on the elevated express train in one direction reached downtown Brooklyn; twenty

Advertisement from *Kingsway Courier* Historical Issue, June 20, 1954

Inner flap matchbook, c. 1942

minutes in the other direction took a rider to Coney Island. In the 1930s the subway system expanded with the addition of the IND system. Then the consolidation of the IRT, BMT, and IND lines carried New Yorkers farther on one fare into southern Brooklyn, beyond Midwood and Flatbush. The Kings Highway cafeteria occupied a block filled with small stores: a newsstand/luncheonette, kosher meat markets, shoe stores, and specialty clothing shops.

Across the street was a Waldbaum's supermarket.[24] Like the Eastern Parkway Dubrow's, the Kings Highway cafeteria was not far from several movie theaters. Nearby, on the corner of East 16th Street and Avenue R, stood the large, prosperous Reform Temple Ahavath Sholom, or "The Avenue R Temple."

Planning for the new Dubrow's revealed enthusiasm for the concept of "a cafeteria of refinement." No longer did a cafeteria imply a fast-food joint or a grab-and-go place.

Dubrow installed a magnificent mural designed by Battisti Studios, which did similar fresco projects for Loew's movie theaters and other fine buildings. He invested in mirrors and recessed lighting in the ceilings arranged in a curving, undulating pattern, and a tall fanciful fountain of glittering mosaics on one wall. Light, pouring in through giant convex plate glass windows, animated the spacious two-story high cafeteria. The new Dubrow's, like Garfield's Cafeteria on Flatbush Avenue, delivered opulence for the cost of a coffee. The environment catered to locals, middle-class Jews from Flatbush and Midwood, as well as Italians and Jews from Bensonhurst and Sheepshead Bay, neighborhoods of modern six-story apartment buildings as well as private and two-family houses.

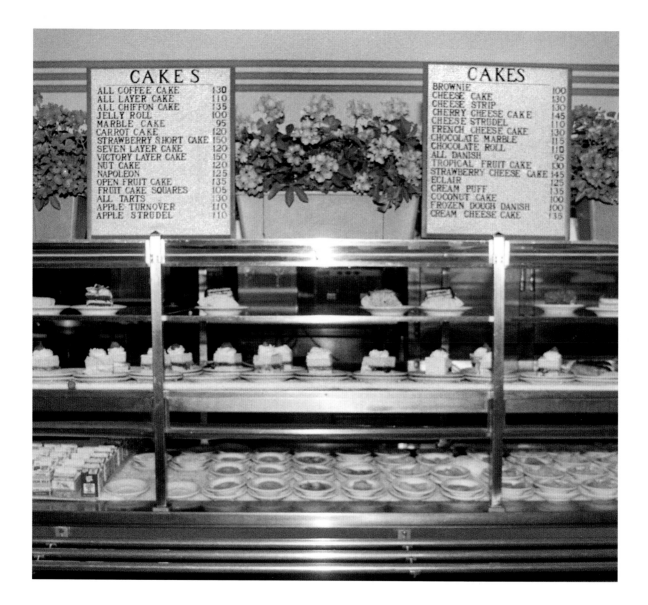

CAKES

ALL COFFEE CAKE	130
ALL LAYER CAKE	110
ALL CHIFFON CAKE	135
JELLY ROLL	100
MARBLE CAKE	95
CARROT CAKE	120
STRAWBERRY SHORT CAKE	150
SEVEN LAYER CAKE	120
VICTORY LAYER CAKE	150
NUT CAKE	120
NAPOLEON	125
OPEN FRUIT CAKE	135
FRUIT CAKE SQUARES	105
ALL TARTS	130
APPLE TURNOVER	110
APPLE STRUDEL	110

CAKES

BROWNIE	100
CHEESE CAKE	130
CHEESE STRIP	130
CHERRY CHEESE CAKE	145
CHEESE STRUDEL	110
FRENCH CHEESE CAKE	130
CHOCOLATE MARBLE	115
CHOCOLATE ROLL	110
ALL DANISH	95
TROPICAL FRUIT CAKE	130
STRAWBERRY CHEESE CAKE	145
ECLAIR	125
CREAM PUFF	135
COCONUT CAKE	100
FROZEN DOUGH DANISH	100
CREAM CHEESE CAKE	135

Dubrow's, Garment
District, 1985

Renewed union conflict at Dubrow's emerged on the heels of initial mobilization for World War II. In February 1942, shortly after the United States entered the war, the Eastern Parkway Dubrow's reached an agreement with Local 325 of the Cooks, Countermen, and Soda Dispensers Union. This time the union won a six-day, forty-eight-hour week, paid vacations, and a closed union shop. Although the union had asked for a raise to $3.00 an hour and Dubrow had offered $2.00

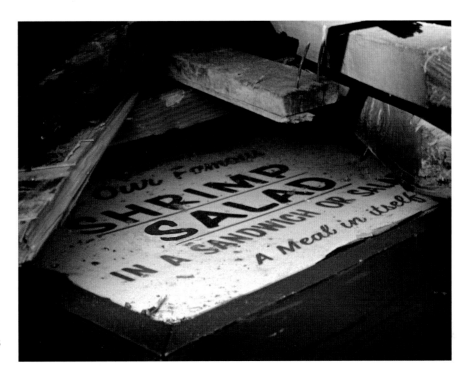

Shrimp salad sign
in a dumpster after
closing, Dubrow's, Kings
Highway, 1978

per hour, they compromised on $2.75 per hour with twenty-five cents being paid to employees in the form of defense stamps.[25] Wartime meant rationing for New Yorkers, but it also brought employment and the end, finally, of the Depression. With so many men in uniform, large numbers of women entered the paid work-force, including married women with children. Both women and men increasingly looked to a cafeteria like Dubrow's to find their favorite foods, redolent of home, at a reasonable cost.

These foods included Jewish staples, such as blintzes, pirogen, gefilte fish, and several different types of kugels. The dairy cooks made hundreds of these items each day while chefs of meat dishes prepared chicken soup and matzo balls, sweet and sour meatballs, and roast chicken. Bakers on the premises churned out pumpernickel, salt sticks, onion rolls, and Kaiser rolls as well as all sorts of cakes: whipped cream cakes and chocolate layer cakes, cheesecakes, and strudel. The range of pies included coconut custard, Boston cream, pumpkin, mince, lemon meringue, and assorted fruit pies.

Unconstrained by kosher guidelines against preparing meals of meat and dairy in a single kitchen, Dubrow's offered a wide array of appetizers: egg salad,

chopped liver, chicken salad, whitefish salad, and three types of herring, including creamed herring.

After the war, more radical menu changes reflected contemporary Jewish eating practices. To satisfy the infatuation of New York Jews with Chinese food, Dubrow's proffered chicken chow mein. Even egregiously *treyf* (unkosher) dishes were available, including shellfish and pork. And among some hardcore denizens of Dubrow's, the shrimp salad entered family lore. "My father who is eighty-four was born and raised in Brooklyn," one person recalled. "He often reminisces fondly about Dubrow's and the shrimp salad he ate there with his friends."[26]

This enormous diversity of freshly made food signified not just something to eat but also a means to nourish friendships and family ties. Dubrow's selection of food sustained both homosocial bonds among clusters of men and women—ties forged in the neighborhood or at work—and heterosocial connections. It was a place to take a date as well as bring the family. "Anytime of the day or night, let's meet at Doob's," recalled one man, using a nickname of the Kings Highway cafeteria.[27] "It was a meeting place. A place to be," remembered Irving Moskowitz. "You didn't get to know them. But they were people, and you sort of knew them."[28] Marcia recollected "different ethnic groups mingling with each other, whether it was day or night." She wrote in her journal about how men, whom she assumed were Italian, "wore the horn necklace, *cornicello*. They were similar in their macho stance to the young Israeli car service drivers who also found a second home there." The Brooklyn artist Ivan Koota noted how people became attached to a specific cafeteria. "At one time, there were several Dubrow's cafeterias in the city," he wrote, "but 'ours' was located on the corner of Kings Highway and E.16th. The prices were right and the choices astonishing, especially the sliced meat sandwiches and the desserts. And following Sunday lunch we often went to a movie. It made no difference if you came in the middle of the film, you just stayed on to see it again."[29]

As the historian of ethnicity James Shenton has emphasized, "the cafeterias were part of Jewish New York." In other cities, "they sprung up near railroad and bus stations, providing good clean cheap food in a hurry. But in New York, cafeterias were places to convene as much as places to eat, like Parisian cafes."[30] New York Jews transformed the cafeteria into an ethnic third place. This term, coined

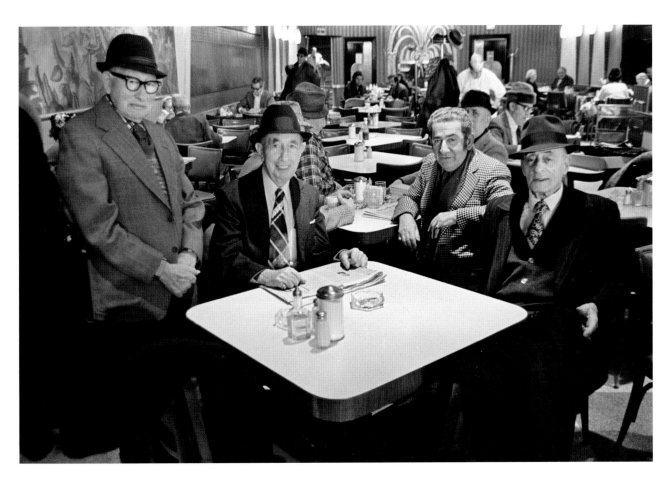

Over-Eighty Club, Dubrow's, Kings Highway, 1975

by Ray Oldenburg, refers to "core settings of informal public life." In contrast to the first two places, namely home and work, the third place designates a "great variety of public places that host the regular, voluntary, informal, and happily anticipated gatherings of individuals beyond the realms of home and work."[31] Cafeterias like Dubrow's became what Oldenburg called, "the Great Good Place." As one Dubrow's patron affirmed, "You go in there, you meet people, the same people. You make friends with people you couldn't find anywhere else."[32]

Dubrow's catered to a diverse, albeit local clientele. Like other Jewish places in the city that were open to all New Yorkers, the cafeteria attracted a multiethnic but primarily white crowd. Its Jewishness stemmed in part from the food served as well as the atmosphere Dubrow promoted. Unlike Horn & Hardart's cafeterias, baked beans and macaroni and cheese did not dominate the menu choices at Dubrow's. Those "American" dishes (especially the pork in the baked beans) appealed to a somewhat different clientele. Of course, Jews ate at the non-Jewish cafeterias as well as at Dubrow's. But they also understood Dubrow's as their place. It competed with other Jewish-owned cafeterias like Hoffman's in Brownsville and Garfield's in Flatbush. Garfield's also adopted the moniker "the cafeteria of refinement" and boasted art moderne mosaics in its interior. In the postwar decades, New Yorkers recognized ethnicity through small differences in style and taste.

Who would occupy the tables at Dubrow's depended on the time of day. Its space allowed for a measure of shoulder-rubbing, as it were, without any actual interactions. Marcia remarks that in the 1970s, when she took photographs in the Kings Highway Dubrow's, New York not only confronted imminent financial collapse, it also endured rising levels of crime. The summer of the blackout and looting in 1977 was also the summer of the "Son of Sam" murders carried out by a Jewish man. "By the late seventies older people were afraid to go out after dark so the crowd would be sparser, younger and mostly men at night," she observed. When she was taking her photographs, "there was this group of Israeli car service drivers who looked out for me and would make sure someone walked me home at night." Her pictures convey this mixture of people. They offer a kind of textbook case, as it were, for Oldenburg's theory about the vitality and importance of third places for all sorts of Americans. The photographs provide, too, a window into New York's unselfconscious Jewish public culture of the 1970s. In her photographs, conversation appears to be as nourishing as eating.

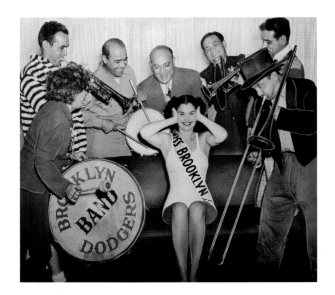 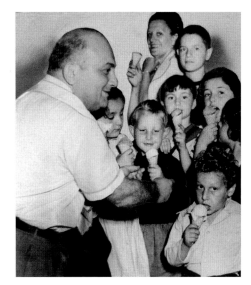

Dubrow's did well during the war years. Both locations flourished. In 1946 George Dubrow, referred to as the "Brooklyn cafeteria king" opened a modernistic, World's Fair–inspired sit-down restaurant near the Eastern Parkway Dubrow's called Dubson's. The restaurant was modeled after the main dining room of the ill-fated *SS Normandie* ocean liner in a *streamline moderne* style. One side of the room was curved and divided into sections with scalloped edges, giving a wave-like effect, and the facing side was a long stretch of glass. The imposing front had tall windows with flowing white drapes twenty-four feet long. It was a popular site for lawyers and politicians and for Dodgers' victory parties.

Then in 1950 he launched a dairy "Founteria," a self-service soda fountain and ice cream bar on Utica Avenue. To celebrate the opening of what turned out to be a short-lived venture, George Dubrow distributed some ten thousand ice cream cones to neighborhood children. The throngs spilled into the intersection of Eastern Parkway and Utica Avenue for the event.

The Founteria also sold fifteen different types of cookies, rum chiffon pie, and ice cream cake for special occasions like birthdays. For those customers who preferred coffee, the Founteria proffered Ehler's coffee, a private local blend. Finally, in the footsteps of other New York Jews, he opened a cafeteria in Miami Beach, on the fashionable shopping area along Lincoln Road.[33]

In 1952, Dubrow made his most important move. With his son, George, who was poised to take over the business, he opened a cafeteria in Manhattan's

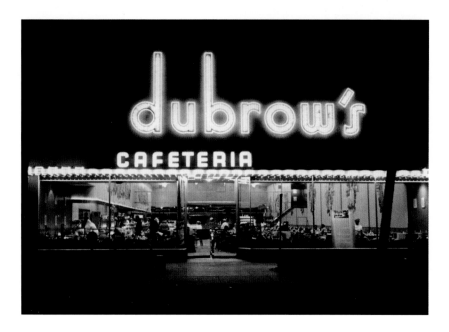

Dubrow's, Miami
Beach, 1952 (© Ray
Fisher)

Garment District, where many Jews worked. With a fifty-year lease, Dubrow
launched his huge eight-thousand-square-foot cafeteria on Seventh Avenue and
38th Street, up the block from the Millinery Center, around the corner from the
Lefcourt and Bricken buildings, and only a block from the Metropolitan Opera
House. It was a prime location to secure patronage from a wide range of cus-
tomers throughout the day and night. Like the Kings Highway Dubrow's, the
Garment Center cafeteria featured an enormous mural. The Garment District
Dubrow's could seat 450 at one time. Its 140-foot-long undulating stainless-steel
counter let customers ogle food before loading a feast (or just a cup of coffee)
onto their mustard yellow trays. By the 1960s it served over five thousand peo-
ple a day.[34]

Dubrow's on Seventh Avenue took elegance to a new level. During dinner
hours it offered, at least for a few years, a roaming dessert cart to diners at their
tables. The cafeteria employed eleven bakers who prepared prodigious quanti-
ties of fresh breads and cakes throughout each day and into the evening. The
dairy cooks made 1,200 truly homestyle blintzes per day—to use one delicious
measure. And, sheer quantity aside, all the food was very good. The prices were
as ever reasonable. The atmosphere, whether boisterous or quiet, was accommo-
dating. The new Manhattan outpost was as *heimish* as the Kings Highway and
Eastern Parkway locations.[35]

AT LONG LAST MANHATTAN HAS A CAFETERIA

in the dubrow *tradition*

250,000 PEOPLE CAN'T BE WRONG

. . . the food-wise diners who came from the four corners of our town to partake of the chef's masterpieces in New York's most magnificent and modern self-service restaurant at . . .

SEVENTH AVENUE AT 38TH STREET

Now, with our courteous personnel fully trained . . . service smoothly efficient, we invite all New Yorkers and visitors to drop in and find the ultimate in taste, quality and value that have made DUBROW'S a . . .

BUY-WORD IN FINE FOODS

BREAKFAST • LUNCHEON • DINNER • SUPPER
AND SNACK TIME ALL THE TIME — Daily and Sunday

THE FAMOUS NAME IN CAFETERIAS FOR THREE GENERATIONS

dubrow's

SELF-SERVICE RESTAURANTS

7TH AVE.
38th ST.

IN
NEW YORK
BROOKLYN
MIAMI
BEACH

TAKE HOME your favorite Dubrow Delicacies
BAKED GOODS • CARVED MEATS • SMOKED FISH • SALADS • APPETIZERS
RETAIL SHOP entrance on **38TH ST.**

LOngacre
3-6300

New York Herald Tribune ad, 1952

37

Then, in March 1956, George Dubrow died in an automobile accident in Florida. Not yet fifty-two years old, his premature death shattered the family. Thousands came to his funeral and a cortege of ninety-three cars accompanied his body to burial in Mount Lebanon Cemetery in Queens. A local paper reported that the crowds at the Park Circle Riverside Chapel, a popular Jewish funeral home, exceeded even those who turned out for the influential Democratic Brooklyn politician, Stanley Steingut. Speakers lauded Dubrow's charitable work, calling him a "true friend and humanitarian" of Brooklyn.[36]

Two years later, Benjamin Dubrow died. In that year the cafeteria chain grossed around six million dollars ($54 million in 2020 dollars). The family business provided a good income for his grandson Irwin Dubrow, who managed the Garment Center Dubrow's, as well as three of his four daughters' husbands: Max Tobin, Irving Kaplan, and Benjamin Adler. Max Tobin, the husband of Minnie Dubrow, had previously joined the family business, taking over responsibility for running the Kings Highway Dubrow's.[37]

The deaths of Benjamin and George Dubrow marked the beginning of Dubrow's declining fortunes. Family businesses struggle with generational transfer. That was complicated in Dubrow's case both by the death of the family's only son and by Benjamin's unwillingness to allow his daughters to enter the business. In 1970, Benjamin's grandson Irwin Dubrow committed suicide in his office at the Garment Center store, prompting shuffling of responsibilities among other male family members.

———————
———————

Dubrow's built its success in part on Brooklyn's growth as a white Jewish borough in the years prior to World War II. When Blacks and Puerto Ricans moved into Brooklyn after the war, they were not welcomed at Dubrow's. Instead, they endured racism perpetrated by white New Yorkers. Jews, Italians, and other white ethnicities increasingly abandoned the city for the suburbs, enticed by federal housing policies that rewarded whites and punished Blacks. Unwilling to share their neighborhood streets with Blacks, many Jews fled the city.

Jewish flight began during the 1950s from working-class Brownsville and accelerated in the 1960s as "red-lining" poisoned the financial viability of entire neighborhoods. Redlined maps delineated investment dead zones, areas where

Blacks were replacing white people, block by block. Redlining made it difficult for landlords to borrow money from banks to maintain or improve properties. In redlined areas, property insurance often became unavailable at any price. Such discriminatory practices curtailed capital improvements by landlords and store owners. The normal, modest flow of private investment to fund new housing, stores, restaurants, or workshops just dried up. Then, as the tax base crumbled, municipal funding for schools and basic infrastructure projects collapsed. A destructive mix of private, city, and federal policies greased the skids for Brownsville's transition from a working-class neighborhood into an area where people struggled to get by, accompanied by an equally dramatic shift in demographics. In 1957 the neighborhood was 66 percent white and Jewish; five years later it was 75 percent Black and Latino.[38] By 1970, only a small number of poor, mostly elderly Jews still lived in Brownsville.

Flatbush was next, as a 1968 *New York Times* article reported. "Once it was a big achievement to live in Flatbush," affirmed Shirley Gerber. "For a Jew coming to Flatbush was a big step up." Not any more. "Property values have dropped." Many Jewish residents of Flatbush were old. They had arrived either during the interwar decades to raise a family or after World War II. In either case, most of their children could afford to leave the neighborhood and they did so in droves. From 1950 to 1960 the number of people over sixty-five rose 42 percent.[39] Yet even in the 1960s, teenagers at James Madison High School cut classes and hung out at Dubrow's on Kings Highway.[40]

Crown Heights also changed in the 1960s. But as some Jews left, others remained, primarily Lubavitch Hasidim. Even as street crime escalated, Rebbe Menachem Schneerson told his followers that they would not abandon the network of parochial schools, shuls, shops, and other communal institutions that they had labored to build. These pious Jews strictly observed kosher laws.[41] They would not consider eating in a non-kosher cafeteria like Dubrow's. The Eastern Parkway Dubrow's was closed by the early 1960s.

Other tastes also shifted, including Jewish preferences for socializing. Going on a date to Dubrow's lost some of its charm and faced new competition. Youth wanted to go to a diner, which usually entailed a car ride, not a subway trip. But in 1962, "a guide to gourmet dining in Brooklyn" recommended two choices for a 3:00 a.m. meal after a late movie: Bernie's or Dubrow's. Bernie's was a "clean

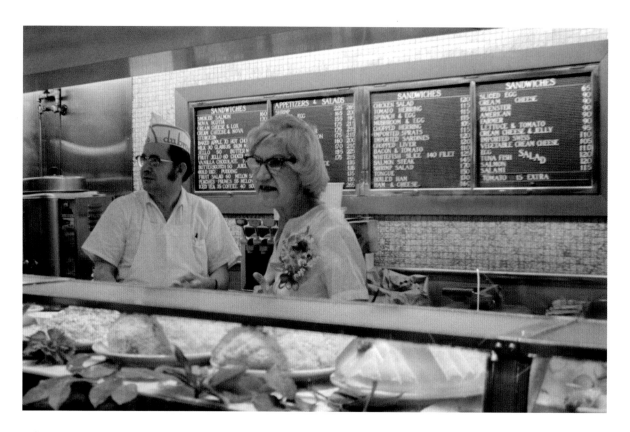

Dubrow's, Kings Highway, 1975

diner" with lots of bagel specialties and good coffee. At Dubrow's, the selection was enormous: "ham and eggs, bacon and eggs and everything else and eggs" were popular. Customers also kept the sandwich man busy with orders for "tuna fish, chopped liver, vegetable cheese, and shrimp salad."[42] The rising popularity of bagels would challenge the diversity and abundance of food orchestrated at Dubrow's.

The city had changed, as had its food tastes. In 1969 the journalist Murray Schumach wrote an article in the *New York Times* chronicling the declining fortunes of cafeterias in the city. Some blamed affluence, others gestured to inflation, and still others cited competition from small stores with low overhead.

Schumach reported that there were probably around one hundred cafeterias in the city, a decline from three hundred a decade earlier. Yet nostalgia colored what counted as a cafeteria. Aficionados excluded company cafeterias as well as automats. "To qualify as a true New York cafeteria," Schumach explained, "the counters should abound with about 300 items, including roast beef, fish, chicken, blintzes, delicatessen, two or three kinds of soup, dozens of sandwiches on several kinds of bread and rolls, a dozen or so salads, stewed and fresh fruit, custard, ice cream, gelatin, sour pickles and tomatoes."

But that wasn't all. "The final hallmark of the New York cafeteria is its atmosphere of noise and frenzy." A true *cafeterianik*, a term coined by the Yiddish writer Isaac Bashevis Singer, finds "the clatter of dishes and cutlery, the crowded tables, relaxing."[43] Considering these high and numerous standards, maybe there were but fifty cafeterias in New York City in 1969.

By the time the Kings Highway Dubrow's closed in 1978, its time had passed. Its closing reverberated among its small coterie of regulars like the death of a dear friend. Many had been coming steadily for years to meet, nosh, and kibbitz. They had grown old with the cafeteria. It was their place and losing it felt personal. In some ways the closing marked the end of an ethnic Jewish way of life among second generation Jews. Cafeterias like Dubrow's connected them to each other, complementing the more intimate bonds of family and the more public commitments of work and politics, worship and recreation. Their children, the third generation, settled in the New York City suburbs; others kept going, scattering across cities in the United States. They might remember Dubrow's with nostalgia, but it wasn't their third place. Neither its décor nor its food, not its location or even the prices appealed to them.

Seven years later, in 1985, Dubrow's on Seventh Avenue shut its doors. The decision to close the still profitable cafeteria reflected real estate deals that were transforming the Garment District. New York was no longer a center of clothing manufacture. The industry had moved to nonunion states and then to Mexico and Asia. Big Apple Garment District buildings attracted real estate speculators. The cafeteria's co-owners, Paul Tobin (Dubrow's grandson) and Irving Kaplan (Sylvia Dubrow's husband), agreed to sell their lease back to the building's owner. The price was right and the future for cafeterias did not look promising. As Tobin told a reporter, the offer made it "'worth our while to get out of the picture."[44]

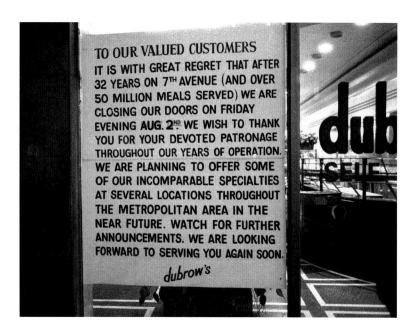

Window sign, Dubrow's, Garment District, closing night, 1985

Dubrow's had served hundreds of thousands of meals over its almost half century of existence. As a family business, it had provided a good living for three full generations.

Second-generation Jews who patronized Dubrow's and other New York cafeterias did not pass their tastes on to their children. Food redolent of comfort, elegance, health, and prosperity to their parents and grandparents was just old fashioned for a younger generation. As New York Jews moved into new white-collar occupations like advertising, engineering, finance, and academia that lifted many of them into the upper and upper-middle classes, eating in a cafeteria did not comport with either their wealth or their self-image. Japanese sushi was the new rage. Even Orthodox Jews could enjoy vegetarian and fresh fish versions of that type of food.

The restaurant business, like the clothing industry, chased fashions decade to decade. Eclectic cuisine combinations attracted adventurous diners.

Jews continued to enter the field as chefs and as business owners. But many of these new popular fast-food places—like Shake Shack, which specialized in hamburgers and hotdogs together with milkshakes, a non-kosher meat and milk combination—did not possess any distinctive Jewish attributes beyond their business ownership. Israeli foods such as hummus and falafel instead occupied the category of what was considered "Jewish" tastes as shops serving these items catered to Israeli immigrants and others in New York.

Thirteen years after Dubrow's closed its last cafeteria on Seventh Avenue, a restaurant with wait staff opened twenty blocks downtown on the corner of Seventh Avenue and 17th Street in Chelsea. Its name was Cafeteria. Unlike the hip Odeon Restaurant on West Broadway in Tribeca that occupied the former Tower Cafeteria and kept its neon sign when it was launched in 1980, Cafeteria deliberately adopted the name in an explicit nod to its twentieth-century predecessors. While it offered a relatively limited menu and stopped serving breakfast at 4:00 p.m., it allowed regulars to linger and stayed open twenty-four hours like its namesakes. It gloried in what could be called "basic" items. "It has avocado toast; it has a kale salad; it has 'street tacos' sold at prices that certainly do not connote any taco found on any street anywhere. Yes, it's basic," affirmed Kayla Kumari Upadhyaya. "Yes, with mac and cheese eggrolls, an early-aughts aesthetic, and 24/7 hours, it's a dinosaur of a restaurant. But it's also perfect." Cafeteria acquired panache in part from being featured in the popular show, *Sex and the City*. It attracted what Kumari Upadhyaya labeled "a fashiony crowd" representing "a genuine blend of low-brow/high-brow."[45]

Yet it also appealed to suburban Jews. Writing in the *New York Times*, Diana Cardwell described it as "a place where those ending their evenings cross paths with those starting their days, where one table might ask for milk in a sippy cup while another asks for more beer." At 2:30 a.m. when she visited, the crowd included a table of high school friends from Port Washington on Long Island, "out for a bite after bar-hopping in midtown"; Andrew Levy, about to finish dental school; David Katz, who researched sepsis; and Hannah Reinhard, self-employed. Cardwell compared Cafeteria to a diner, an apt comparison.[46] Yet its choice of name, along with its menu, illuminates the city's shifting tastes even as it pays homage to an era when "cafeteria" evoked a rather different mood and ethos.

Notes

1. Daniel Katz, "From Yiddish Socialism to Jewish Liberalism: The Politics and Social Vision of Pins and Needles, 1937–1941," *All Together Different: Yiddish Socialists, Garment Workers, and the Labor Roots of Multiculturalism* (New York: New York University Press, 2011), 201–31. For reference to the song, see 218. For lyrics, *All Together Different: Yiddish Socialists, Garment Workers, and the Labor Roots of Multiculturalism* see "Mene Mene Tekel (1939)," *A Song Every Day*, https://songeveryday .org/exploring-babylon/mene-mene-tekel/, accessed June 11, 2020.

2. Irving Howe, "A Memoir of the Thirties," *Steady Work* (New York: Harcourt, Brace & World, 1966), 354–55.

3. John F. Mariani, "Cafeteria," *Encyclopedia of American Food and Drink* (New York: Bloomsbury, 2013).

4. The Belmore, a cafeteria on 28th Street in Manhattan that was open twenty-four hours, attracted cab drivers. It closed in 1981.

5. Christopher Klein, "Birth of a Fast Food Nation," *History*, July 13, 2012, updated August 22, 2018, https://www.history.com/news/the-automat -birth-of-a-fast-food-nation.

6. See "automats," in *Encyclopedia of New York City*, ed. Kenneth T. Jackson (New Haven: Yale University Press, 1991), 67.

7. "Cafeterias: Manhattan," *1970 New York Hackmen's and Chauffeur's Guide*, 11th rev. ed. (Scarsdale, NY: Thurston Publishing Company, 1969), 92–93.

8. Murray Schumach, "Cafeterias Becoming Casualties of Age of Affluence," *New York Times,* April 18, 1969.

9. Deborah Dash Moore, *At Home in America: Second Generation New York Jews* (New York: Columbia University Press, 1981), 21.

10. These included the requirement that meat be kept no more than three days after butchering.

11. See "kosher foods," *Encyclopedia of New York City*, 642.

12. See "bakeries," in *Encyclopedia of New York City*, 71.

13. Suzanne Spellen, "The Glamorous Magical Fantasy World of Loew's Pitkin Avenue Theater," *Brownstoner*, September 20, 2017, https:// www.brownstoner.com/architecture/brooklyn -architecture1501-pitkin-avenue-loews-theatre -brownsville/. The theater was designed by Charles Lamb.

14. Moore, *At Home in America,* 23.

15. "Dubrow is Dead; Ran Cafeterias," *New York Times,* July 22, 1958.

16. Beth Wenger, *New York Jews and the Great Depression: Uncertain Promise* (Syracuse: Syracuse University Press, 1996), 11.

17. "Unions Restrained by Court Decision," *Brooklyn Times Union,* November 23, 1932. See also *Columbia Law Review* 33, no. 1 (January 1933): 165–67. Britt Tevis explains, "The case did not break new ground, but it was part of a larger group of cases compiled in the Brissenden Study in which workers were trying to establish a right to protest and ensure certain workplace rights and, at the same time, courts were trying to navigate granting protestors the right to strike, picket, while also preventing that very thing." The guide to materials in the study explains: "Certainly, the Norris-LaGuardia 'Anti-Injunction' Act of 1932 was not the result of the Brissenden Study alone, but rather of many years of labor agitation and Congressional inquiry. The Brissenden Study did, however, provide an illuminating analysis for those legislators who sought to correct a judicial imbalance in the collective bargaining structure." Email correspondence with author, June 3, 2020.

18. "Labor Law. Peaceful Picketing. Coercion of Employer to Change Business Not a Justification," in *Columbia Law Review* 33, no. 1 (January 1933): 165–67. Explanation from Mik Moore, email correspondence, May 31, 2020.

19. Wenger, *New York Jews and the Great Depression,* 16–17.

20. Interview with Henry Jablonski, part 3, March 21, 2010, *Dubrow's Cafeteria,* http://dubrows.blogspot.com/search/label/oral%20history, accessed June 15, 2020.

21. Interview with Henry Jablonski, part 2, March 16, 2010, *Dubrow's Cafeteria,* http://dubrows.blogspot.com/search/label/oral%20history, accessed June 15, 2020.

22. "Babchik Clews Are Offered by His Chauffeur," *New York Herald Tribune,* September 27, 1941.

23. "Restaurant Lease," *Brooklyn Daily Eagle*, October 29, 1939, p. 25.

24. Robert Williams, "Dubrow's—A Brooklyn Legend," blog post, May 25, 2010, http://robertwilliamsofbrooklyn.blogspot.com/2010/05/dubrows-brooklyn-legend.html, accessed June 15, 2020.

25. "Contract Provides Defense Stamp Payment," *The Brooklyn Daily Eagle,* February 14, 1942, 1.

26. "More Reader Feedback" (Sue), *Dubrow's Cafeteria,* June 11, 2008, http://dubrows.blogspot.com/search?q=shrimp+salad.

27. AP archive video of Bob O'Brien, on Dubrow's closing at Kings Highway, *Channel 5 News*, September 19, 1978.

28. Quoted in Dena Kleiman, "Dubrow's Serves Last Apple Strudel," *New York Times,* August 3, 1985.

29. Ivan Koota, "Dubrow's Cafeteria," *Brooklyn Places: Paintings of Brooklyn by Ivan Koota,* http://www.brooklynplaces.com/index_files/Page493.htm, accessed June 14, 2020.

30. Quoted in Irene Sax, "The Last Cafeteria," *Newsday,* June 12, 1985, B15.

31. Ray Oldenburg, *The Great Good Place: Cafes, Coffee Shops, Community Centers, Beauty Parlors, General Stores, Bars, Hangouts, and How They Get You Through the Day* (New York: Marlowe, 1991), 16.

32. AP archive video of Bob O'Brien, on Dubrow's closing at Kings Highway, *Channel 5 News*, September 19, 1978.

33. *Brooklyn Eagle,* July 31, 1950.

34. Robert Metz, "Loss Leaders Draw Cafeteria Customers," *New York Times,* October 26, 1971; Dena Kleiman, "Dubrow's Serves Last Apple Strudel," *New York Times,* August 3, 1985.

35. Robert Metz, "Loss Leaders Draw Cafeteria Customers," *New York Times,* October 26, 1971.

36. "George Dubrow," *Williamsburg News,* March 16, 1956, p. 3.

37. "Dubrow is Dead; Ran Cafeterias," *New York Times*, July 22, 1958.

38. Deborah Dash Moore et. al., *Jewish New York: The Remarkable Story of a City and a People* (New York: New York University Press, 2017), 290–91.

39. Quoted in "After Era of Stability, Flatbush Yields to Change," *New York Times,* February 14, 1968.

40. Williams, "Dubrow's—A Brooklyn Legend."

41. Moore et. al., *Jewish New York*, 292.

42. "Fit for Kings," *Kings Courier,* Saturday, May 19, 1962, p. 11. Robert Williams writes "This was about 1961." Williams, "Dubrow's—A Brooklyn Legend."

43. Murray Schumach, "Cafeterias Becoming Casualties of Age of Affluence," *New York Times*, August 18, 1969.

44. Quoted in Dena Kleiman, "Dubrow's Serves Its Last Apple Strudel," *New York Times,* August 3, 1985.

45. Kayla Kumari Upadhyaya, "Long Live Cafeteria, Chelsea's Eccentric 24/7 Time Capsule of the Early Aughts," *Eater New York,* July 15, 2019, https://ny.eater.com/2019/7/15/20692103/cafeteria-chelsea-ode-nyc-still-open.

46. Diana Cardwell, "Comfort Food, All Day and All Night Long," *New York Times,* April 15, 2011, https://www.nytimes.com/2011/04/17/nyregion/series-at-the-table-at-cafeteria-comfort-food-all-day-and-all-night-long.html?_r=0.

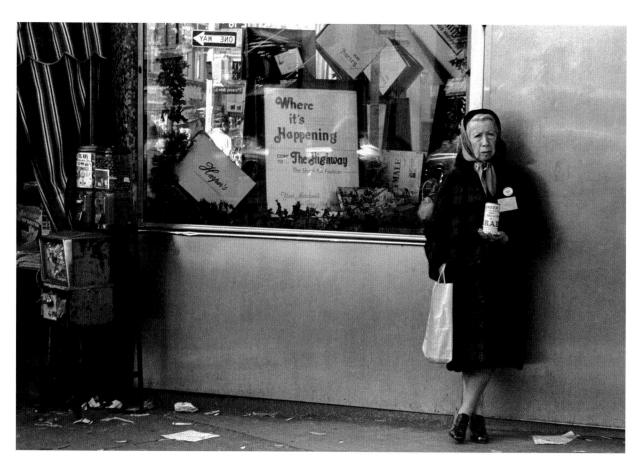

Woman with charity *pushka* collecting for Pioneer Women,
a Zionist women's organization, outside Dubrow's, 1975

dubrow's, kings highway, brooklyn

Where It's Happening, Come to the Highway

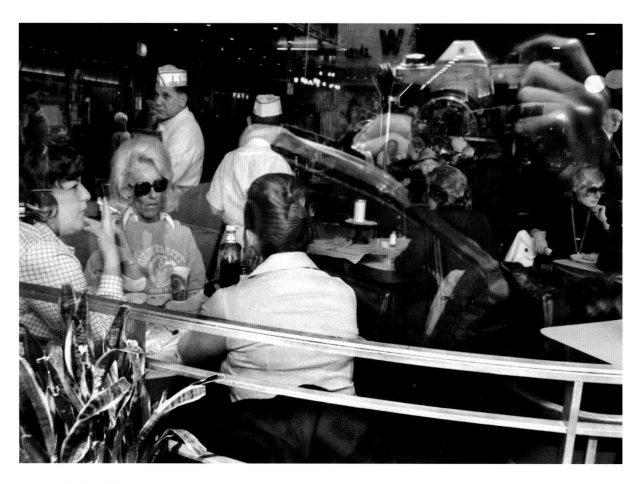

Camera reflection, 1975

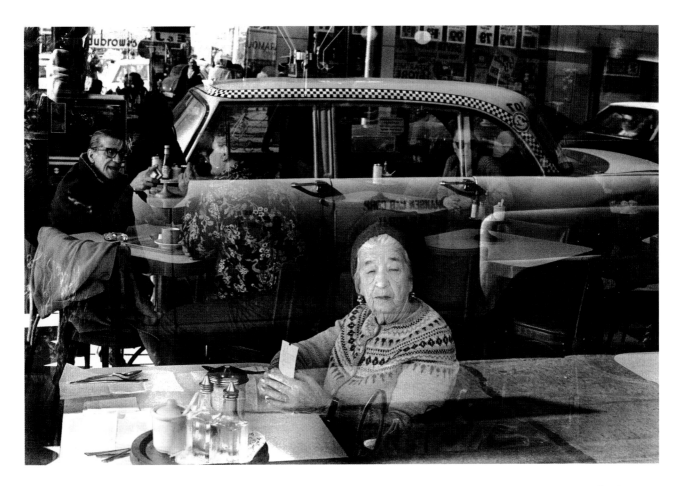

Reflections, 1975

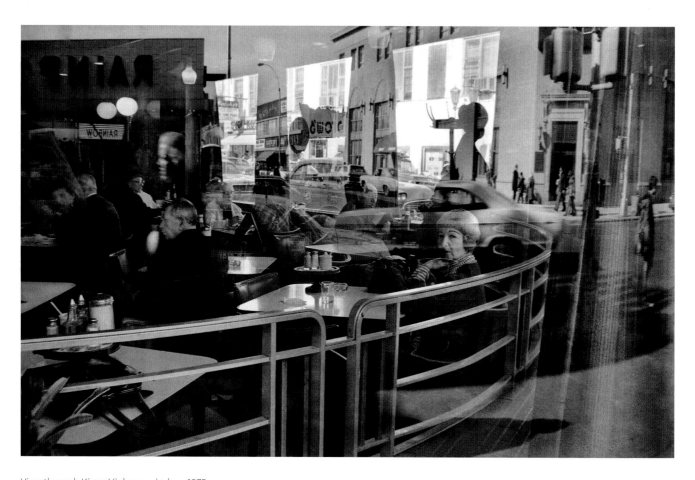

View through Kings Highway window, 1975

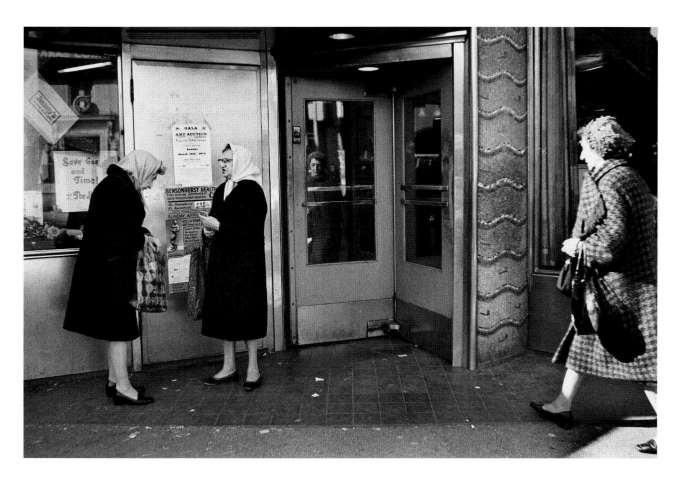

Revolving doors, 1975

Hyman Kornblum, 1976. Beginning when he was eighty years old and continuing to the age of ninety-three, Mr. Kornblum worked giving out the tickets from a dispensing machine that gave a glorious mechanical cha-ching. This was an important job as it ensured that patrons did not take two tickets and attempt to beat the system with a cup of coffee on one and a full-course meal on the other.

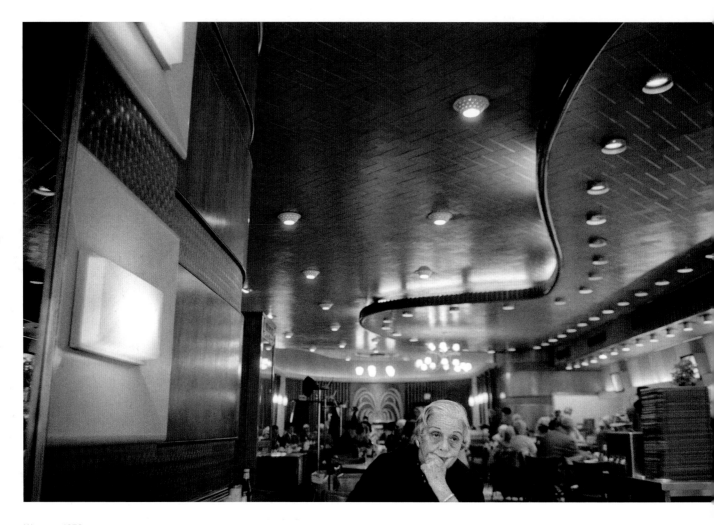

Woman, 1976

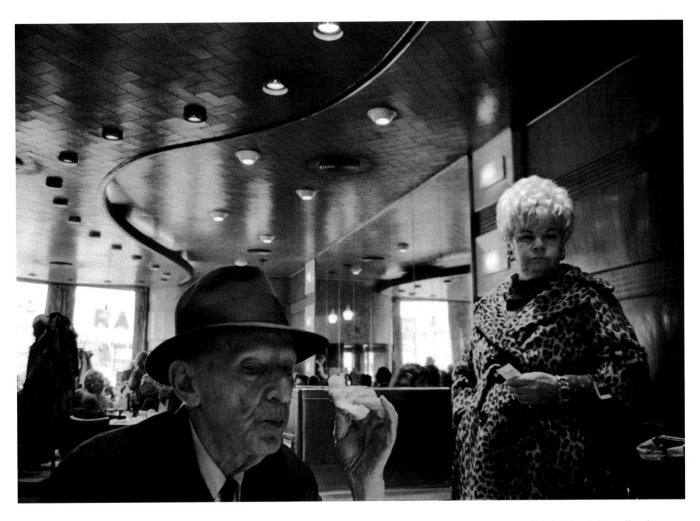

Man holding Kaiser roll and woman
holding check, 1975

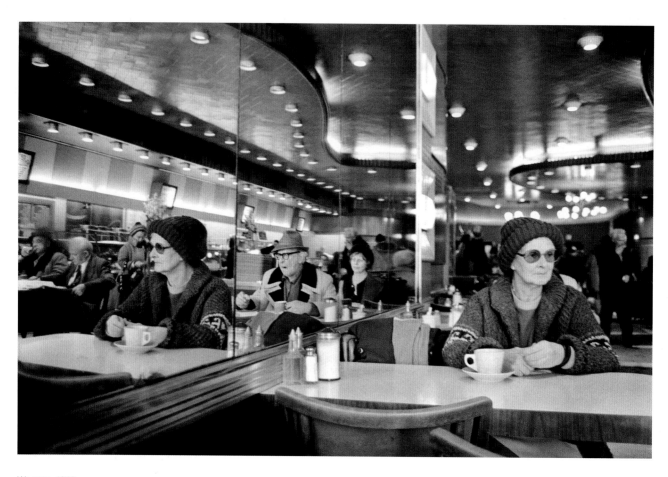

Woman, 1975

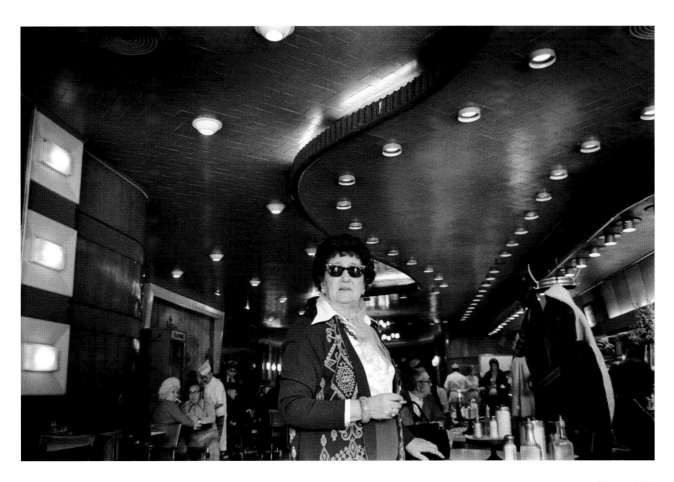

Woman, 1975

Man with check, 1975

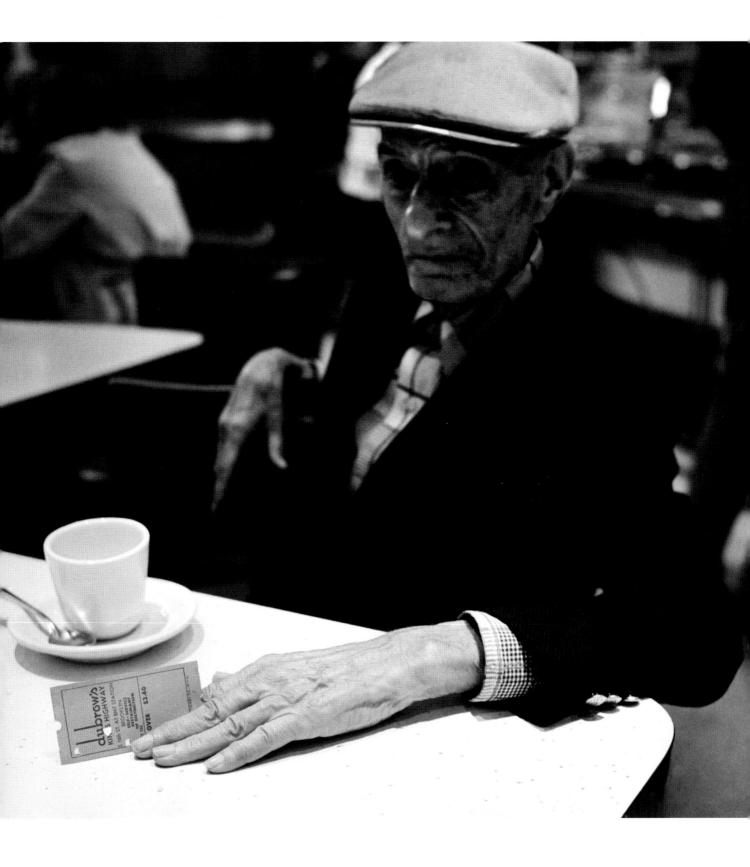

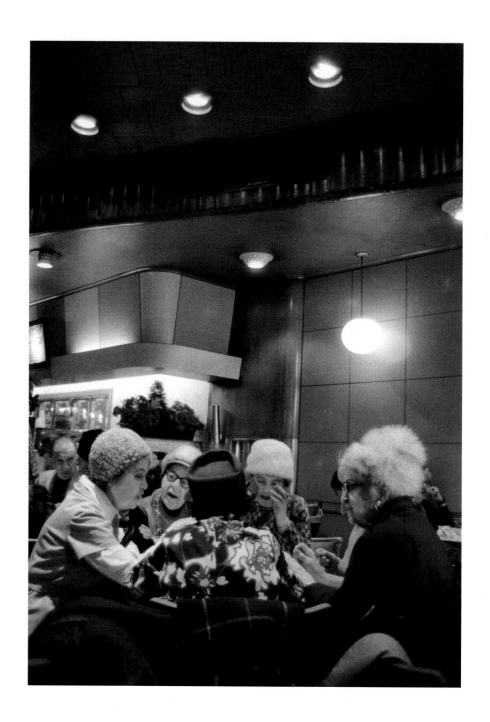

Women with
hats, 1975

60

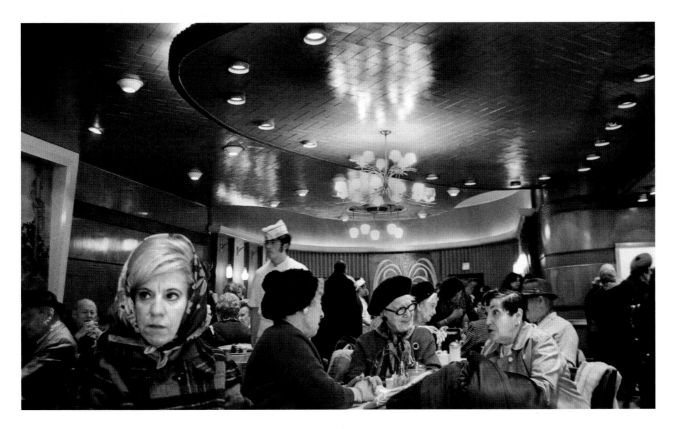

Women, 1975

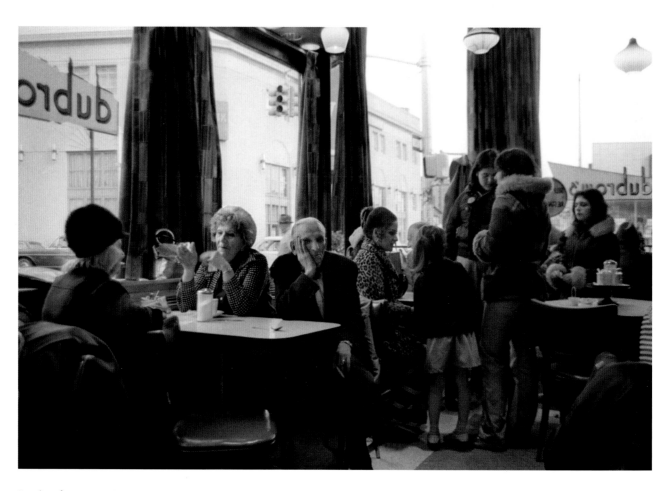

Sunday afternoon, 1975

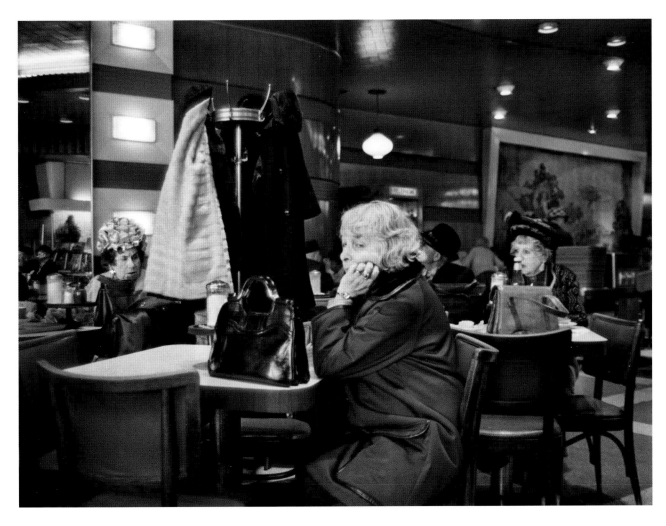

Three women, 1975

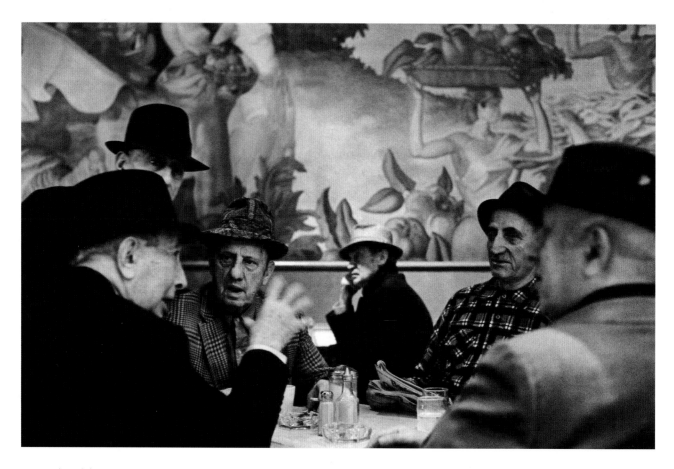

Over-Eighty Club, 1975

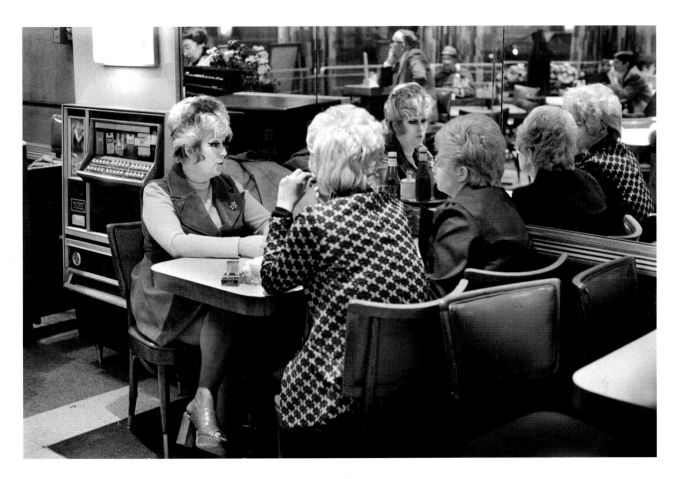

Evening out, 1975

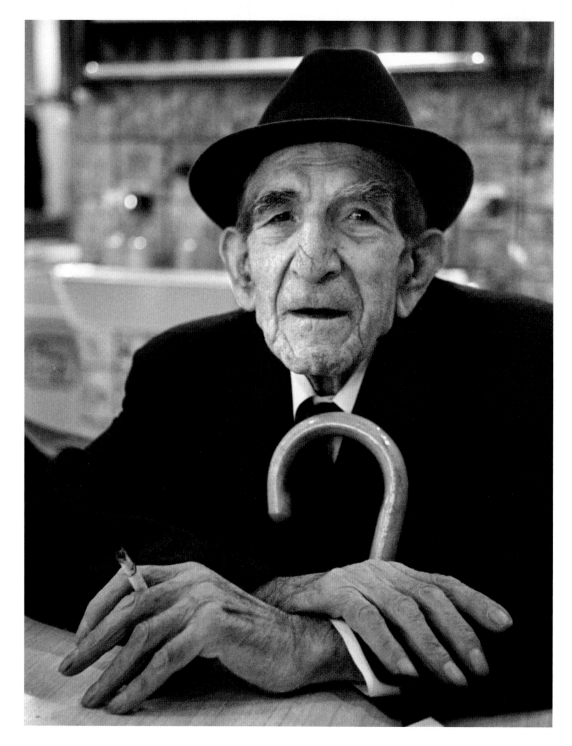

Man with cane, 1977

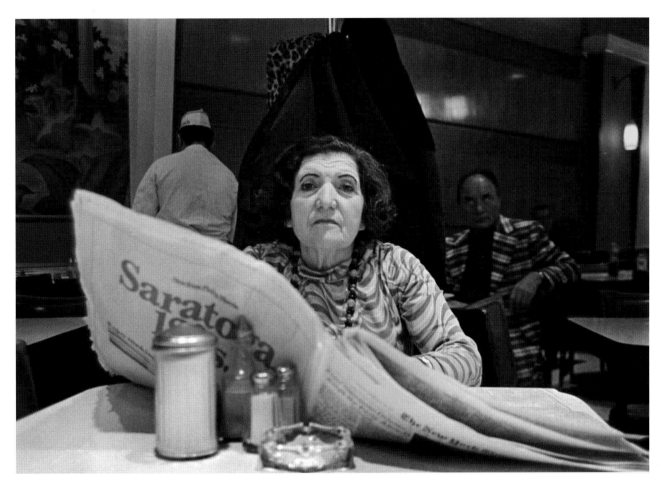

Woman with newspaper, 1975

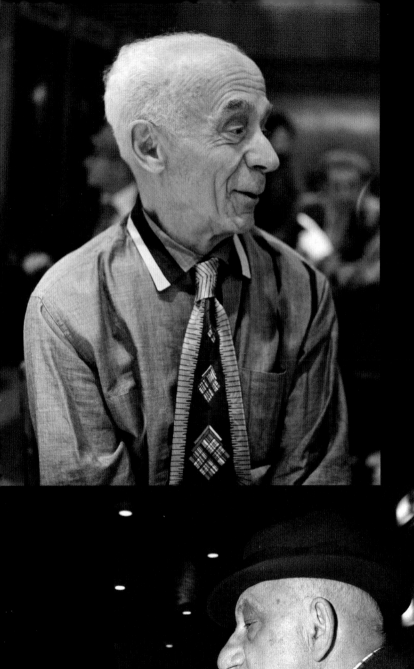
Men, 1975
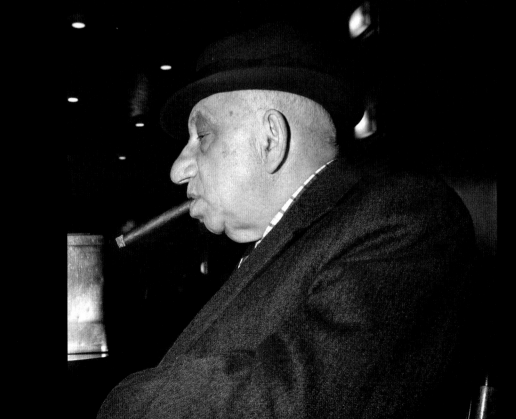

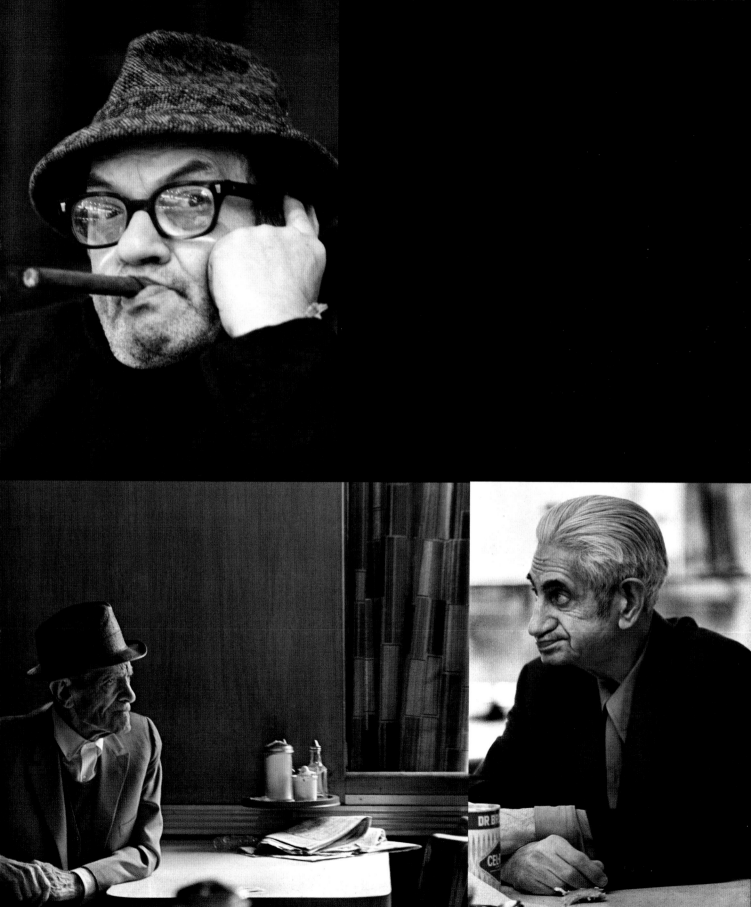

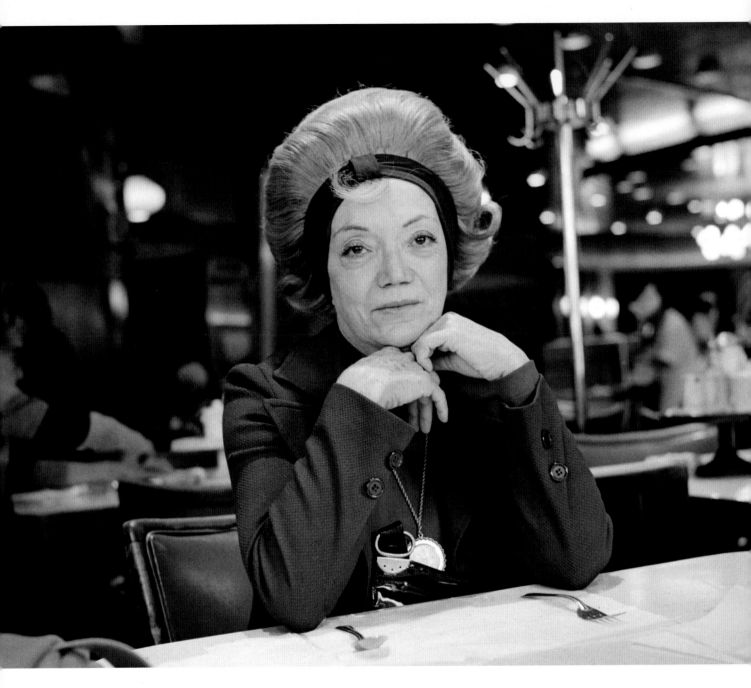

Woman with curl, 1975

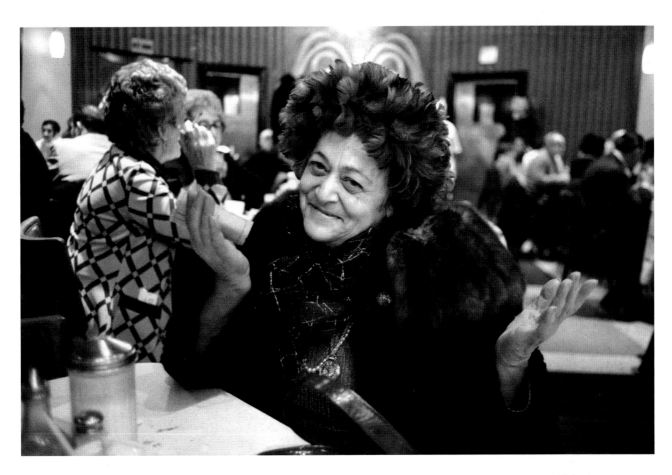

Woman with feathered hat, 1975

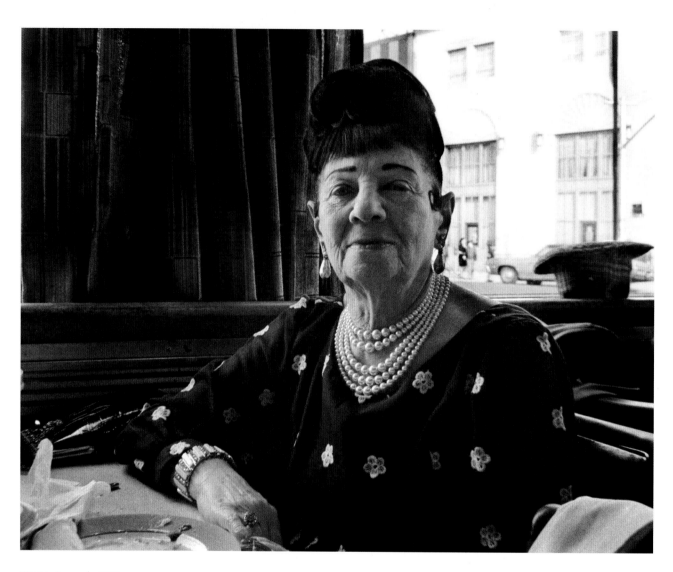

Woman in pearls, 1975

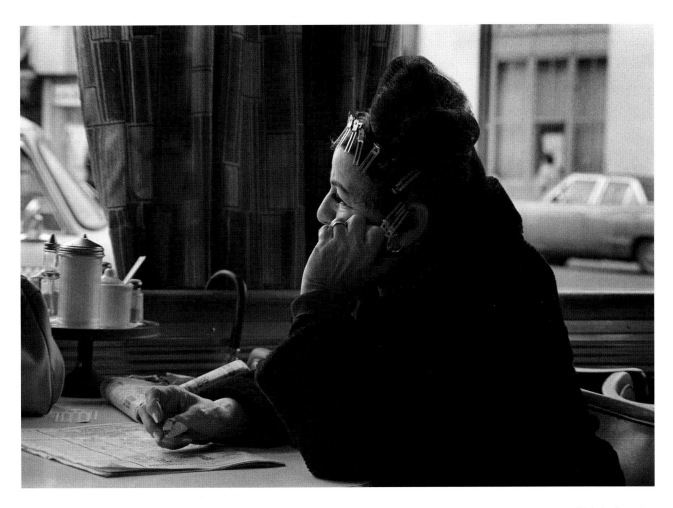

Woman with hair clips, 1975

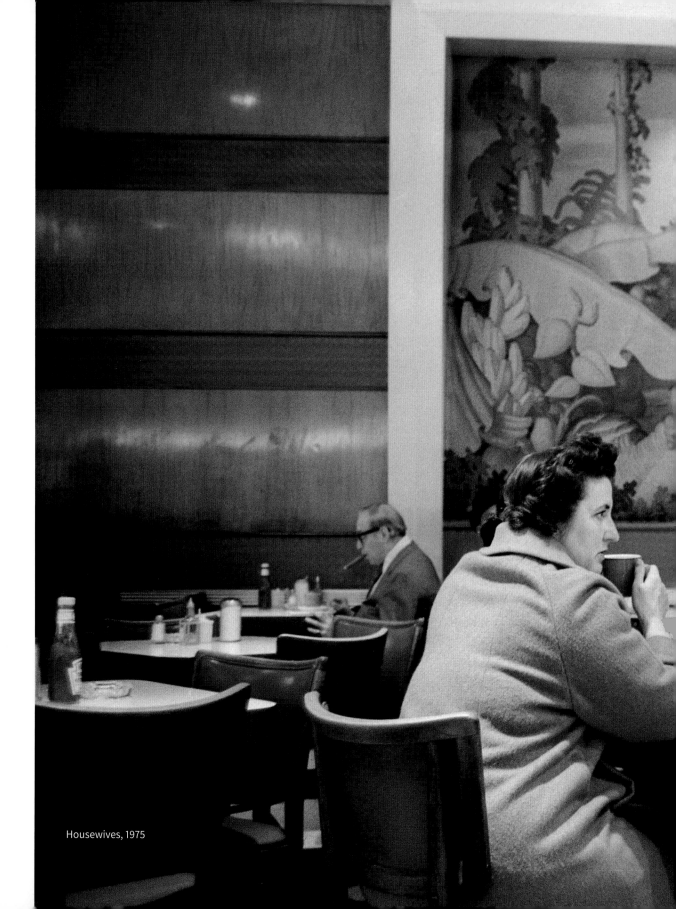

Housewives, 1975

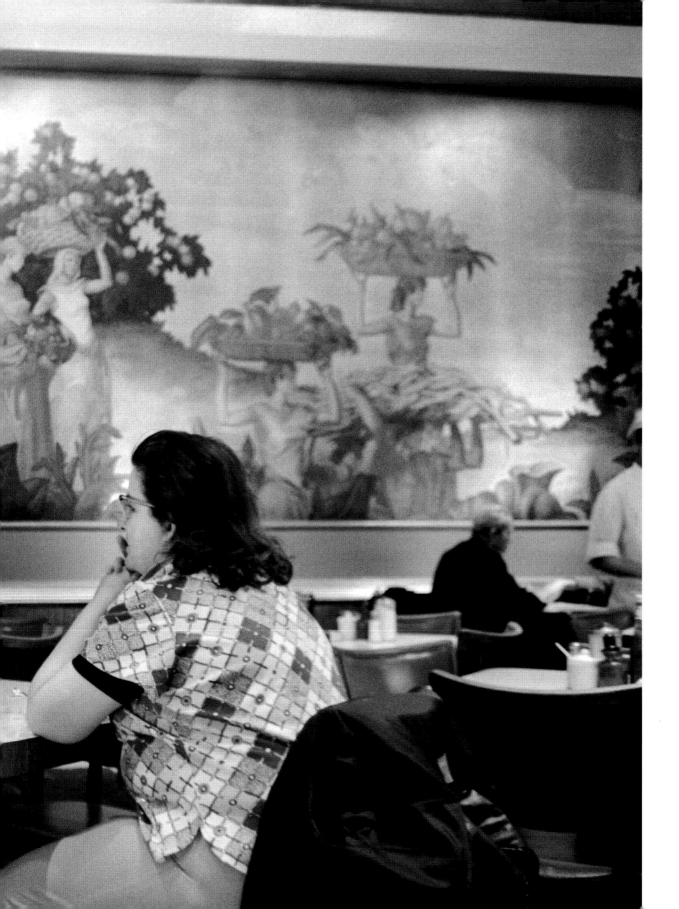

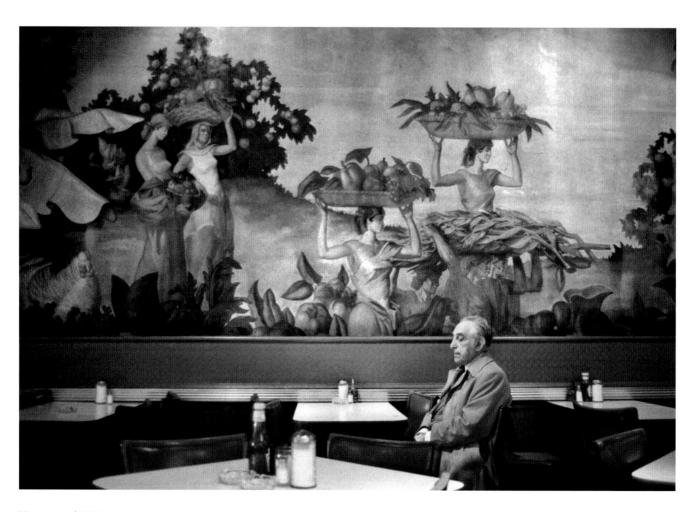

Man at mural, 1976

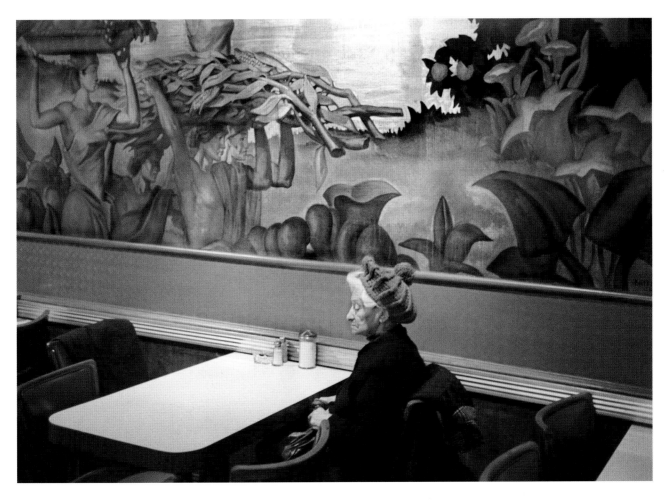

Woman at mural, 1977

The pink lady, 1975. This is one of the few photographs I regret not taking in color. Sitting against a puce-colored wall, wearing a pink angora hat and cardigan, this woman had just finished applying fresh pink lipstick. She was about to have her cherry Jello and Calypso Cooler. Beet-colored horseradish and ketchup completed the warm color palette.

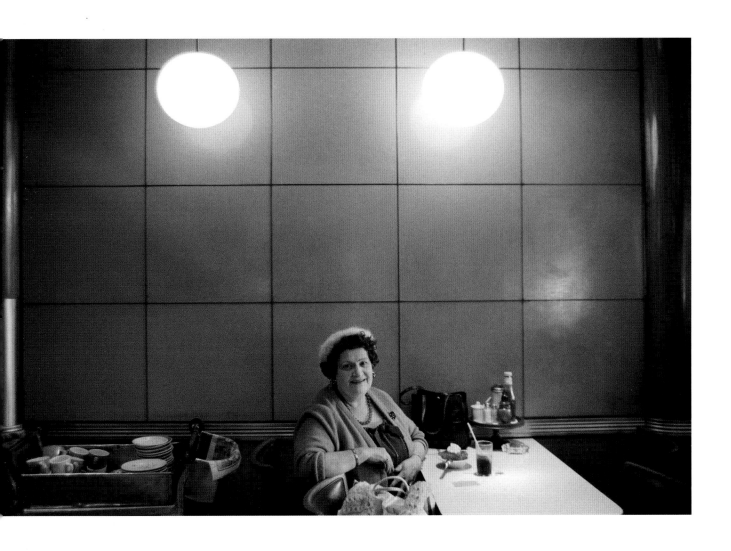

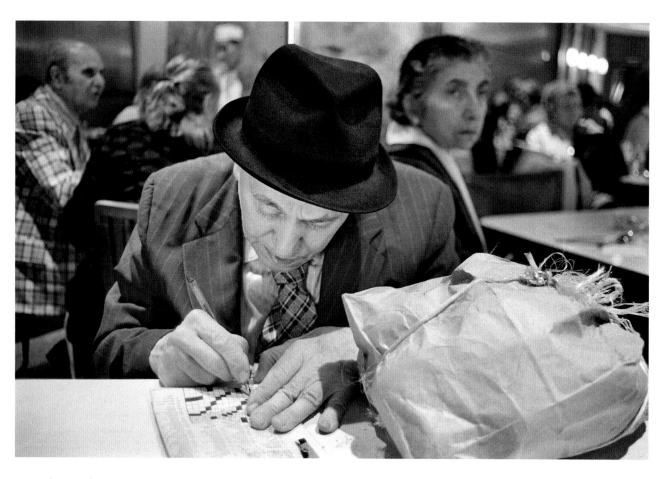

Man with a parcel, 1975

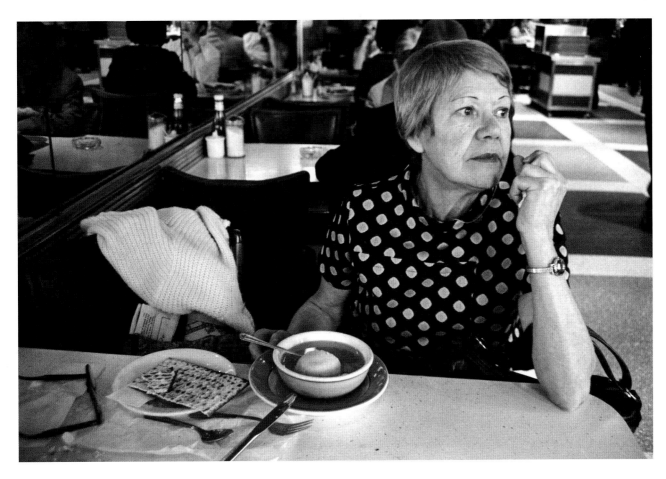

Woman having matzo ball soup, Passover, 1975

The bounty of offerings, the anxiety of having too many choices, the urgency of moving down the line, and the giddiness of piling one's tray full of good food at a cheap price constitutes America eating in its most fundamental, democratic form.

—John F. Mariani

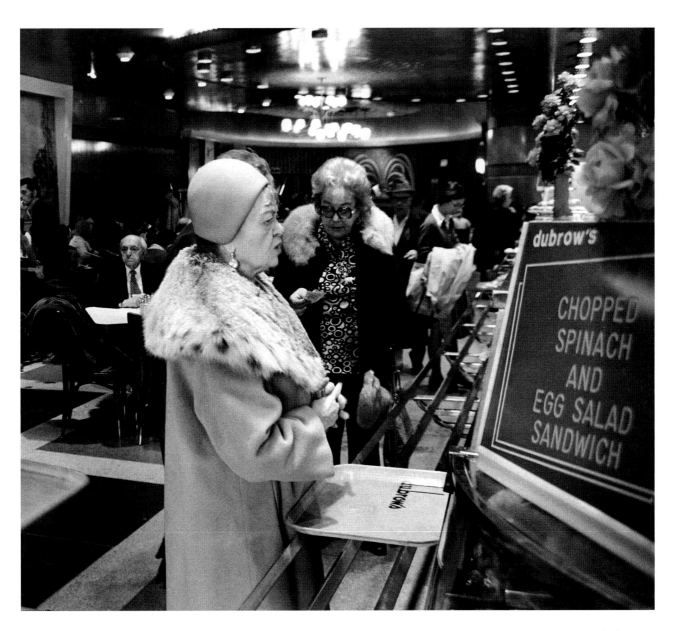

The sign on the image reads:

dubrow's

CHOPPED
SPINACH
AND
EGG SALAD
SANDWICH

Woman in cloche hat, 1975

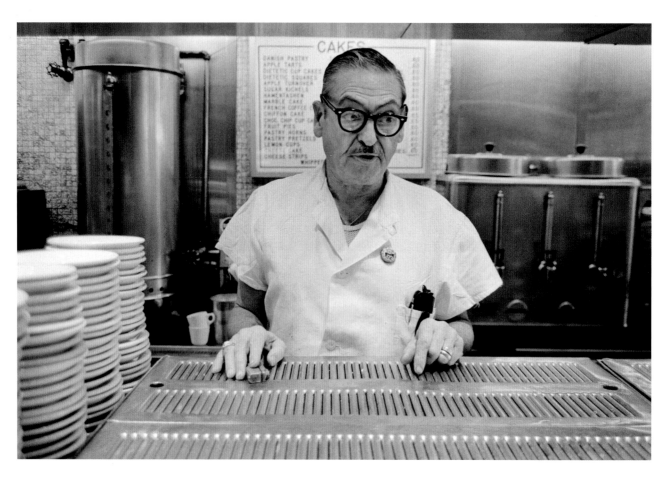

Dave wearing a Local 325, Cooks, Countermen,
and Soda Dispensers union button, 1975

Dubrow's Cafeteria

ISIDORE CENTURY

In time for the half-price dinner special,
you slide your tray along the steam table
with the selections you have made from
juice or soup,
two veggies (no salad),
chicken or fish,
rye, white or whole wheat bread,
rice pudding or jello,
coffee or tea.
No exceptions!
You pause to look down at your choices;
there is barely room for knife and fork.

The man behind the counter asks,
"Maybe something else?"
You look at your tray once more;
a Jewish mother's delight.
You look at the counter man's pallid face;
it resembles your father's.
"How about a kiss?" you hear yourself say.
A wisp of a steamy smile passes over his lips.
"That's a good one," he says,
and hands you a dish of kasha varnishkas.
From somewhere on the line behind you
a prophetic voice calls out,
"Comes the revolution we will all get kasha varnishkas."
"But I don't like *kasha varnishkas*," another voice says.
"Like them or not, you will get kasha varnishkas."

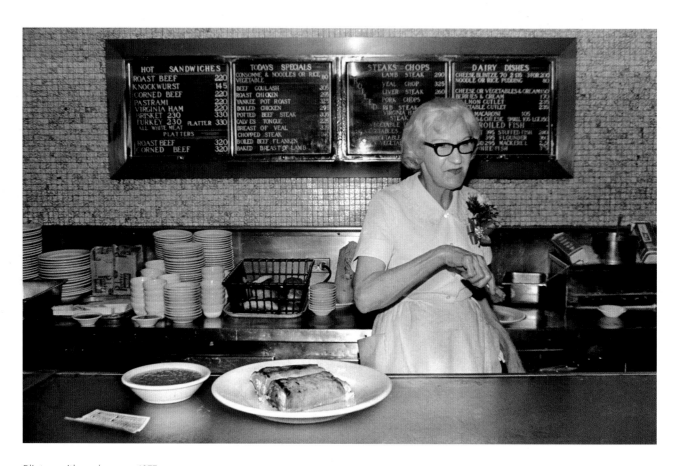

Blintzes with apple sauce, 1977

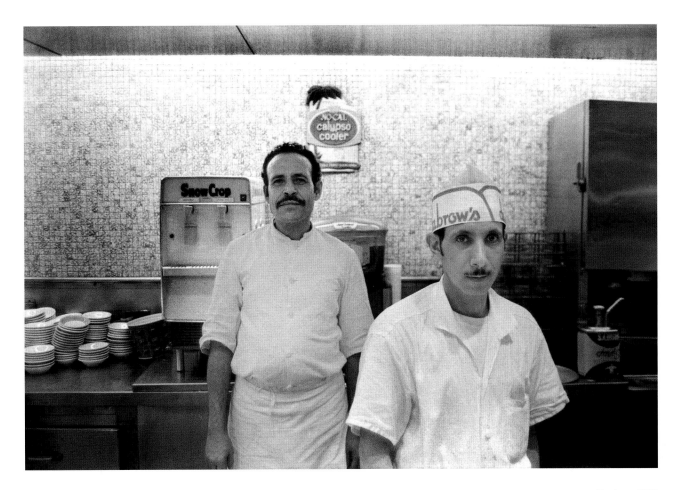

Busboys, 1975

87

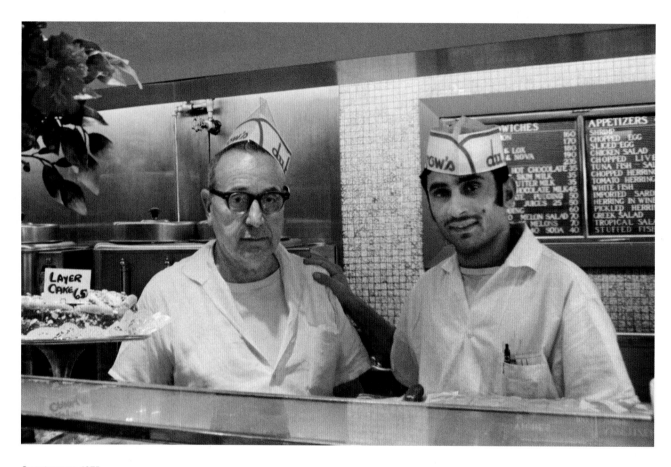

Countermen, 1975

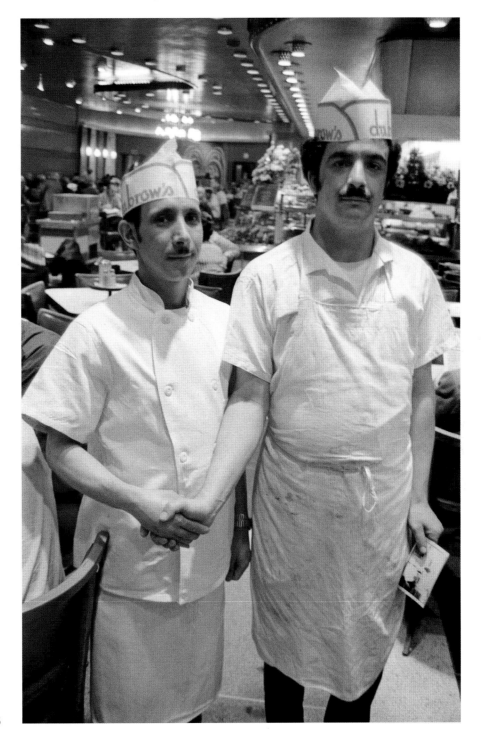

Busboys, 1975

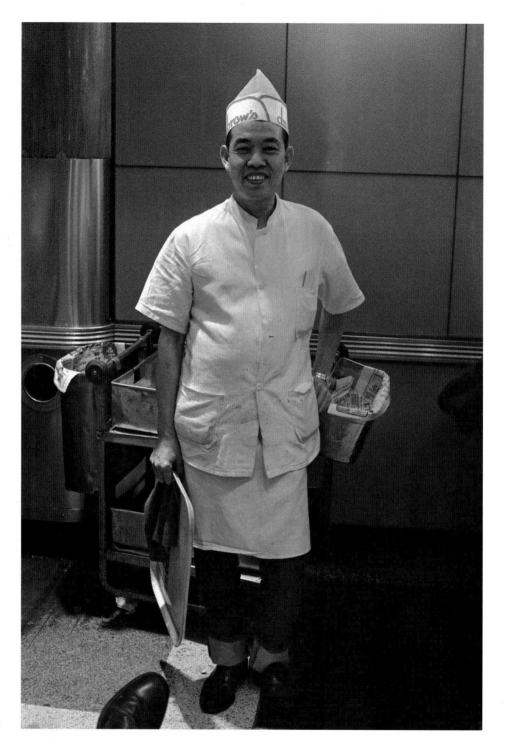

Busboy, 1975

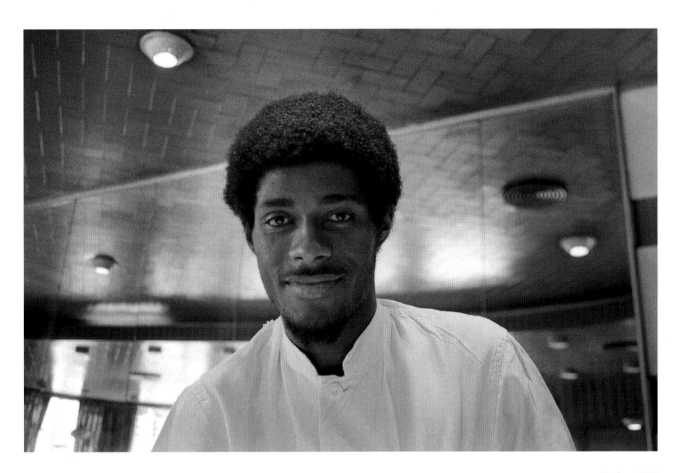

Busboy, 1976

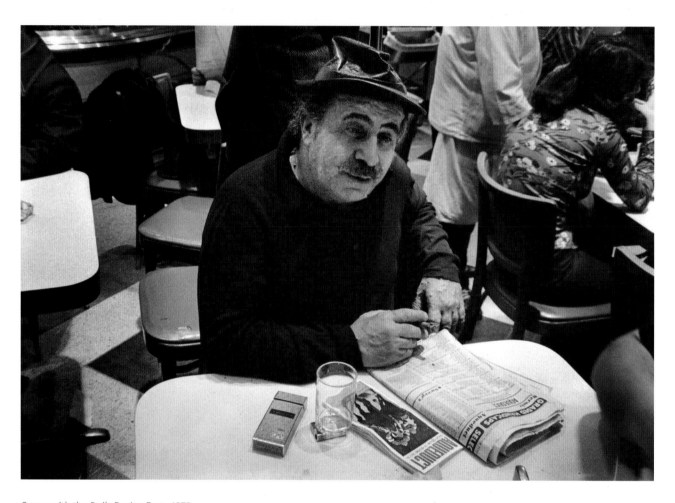

Cappy with the *Daily Racing Form*, 1975

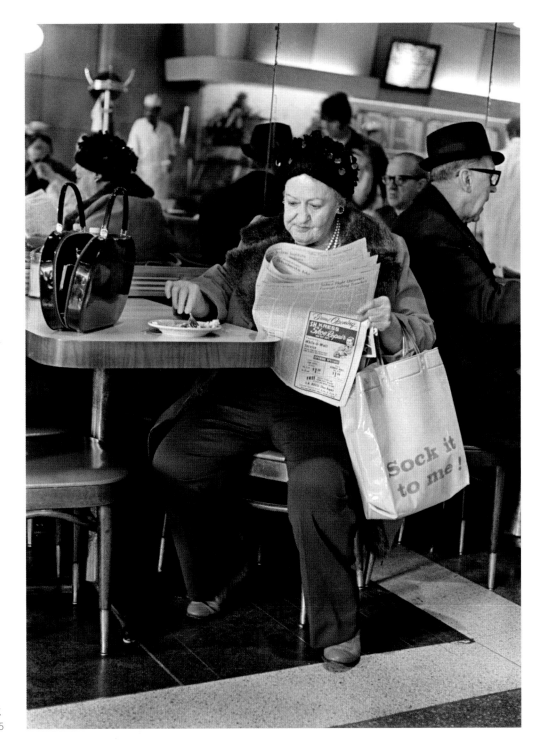

Woman eating
cream pie, 1975

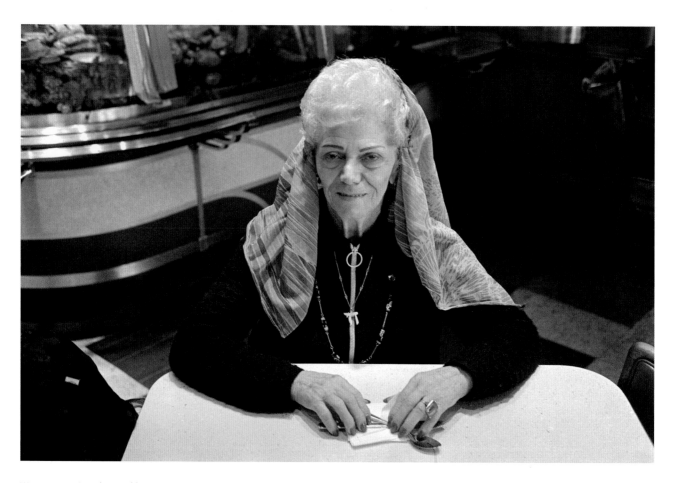

Woman wearing *chai* necklace, 1976

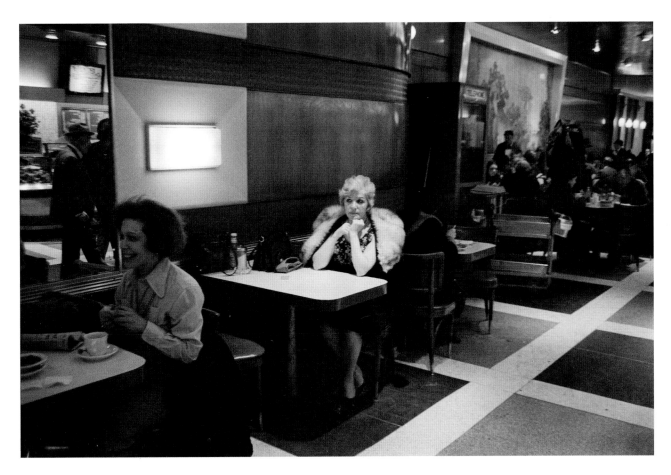

Saturday night, 1975

Couple at night, 1975

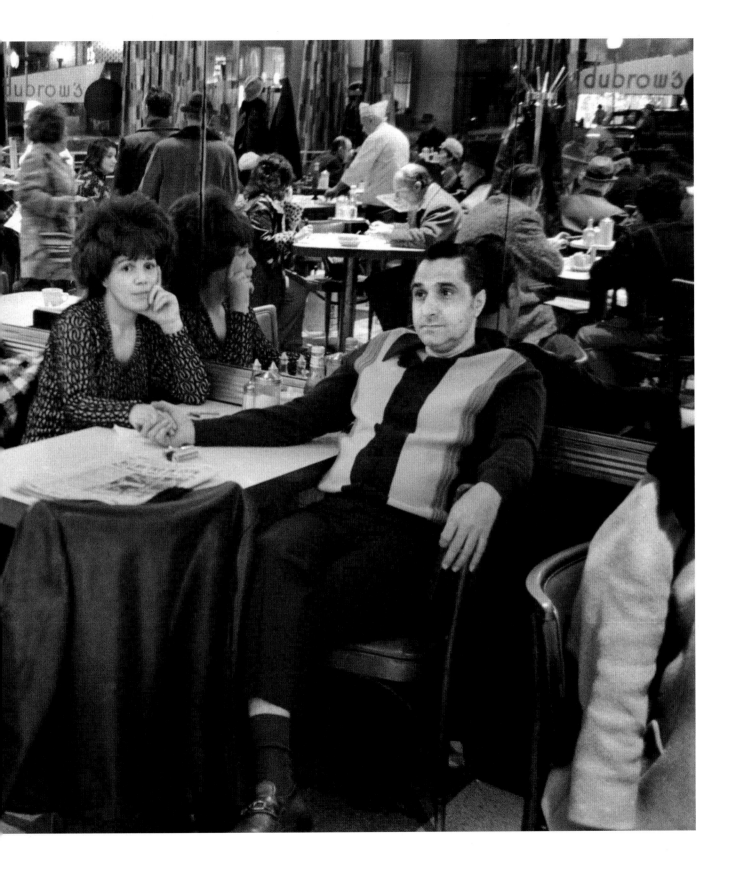

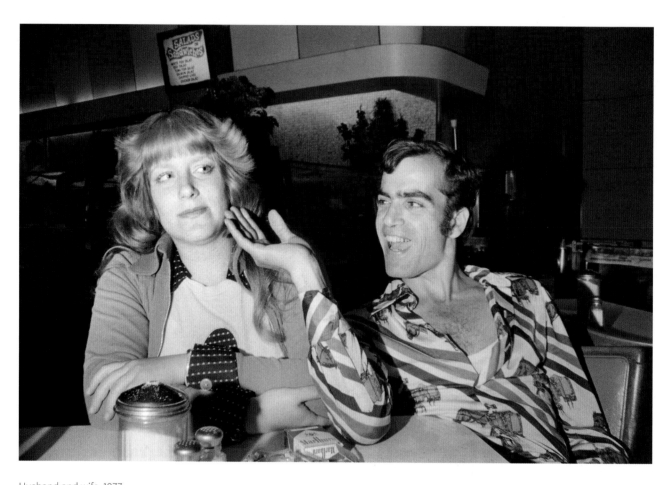

Husband and wife, 1977

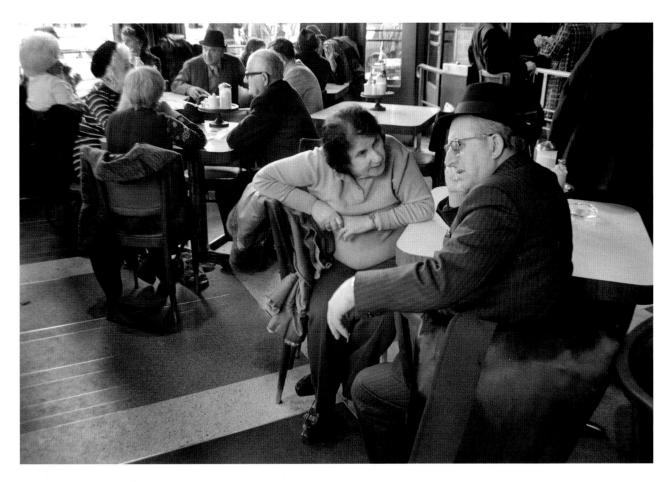

Husband and wife, 1975

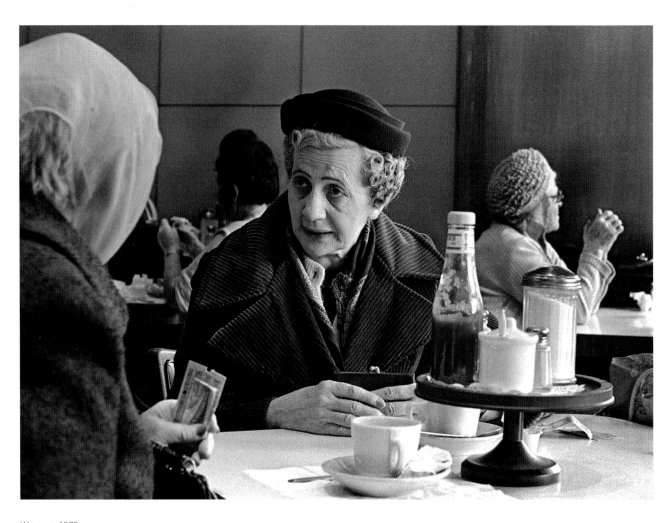

Women, 1975

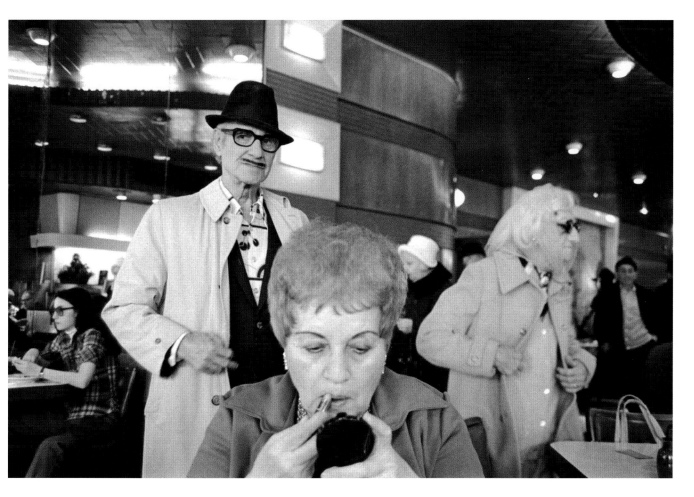

Woman putting on lipstick, 1977

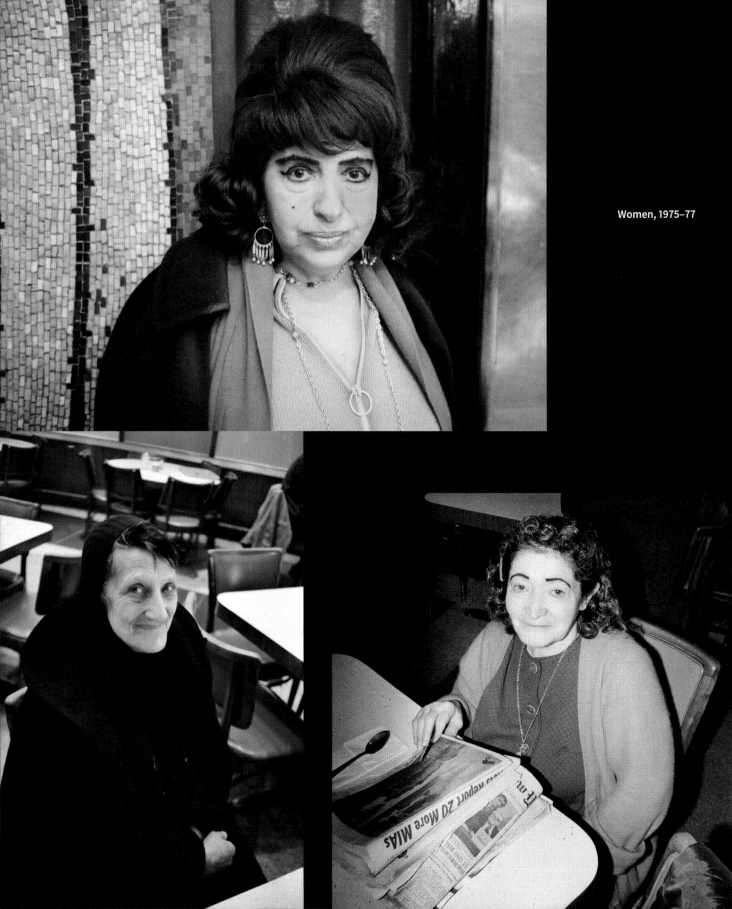

Women, 1975–77

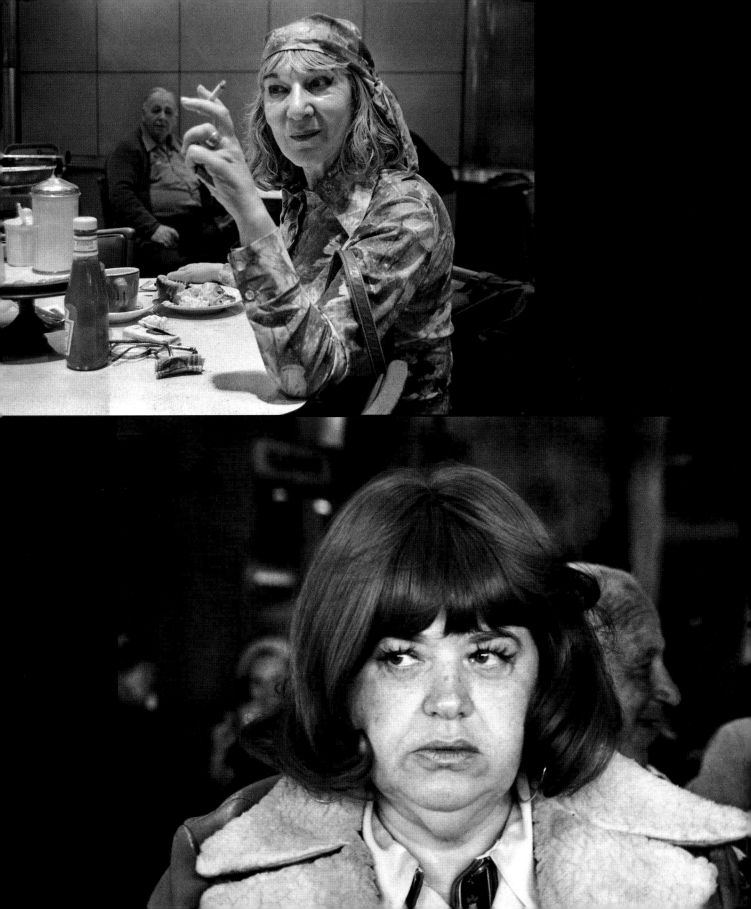

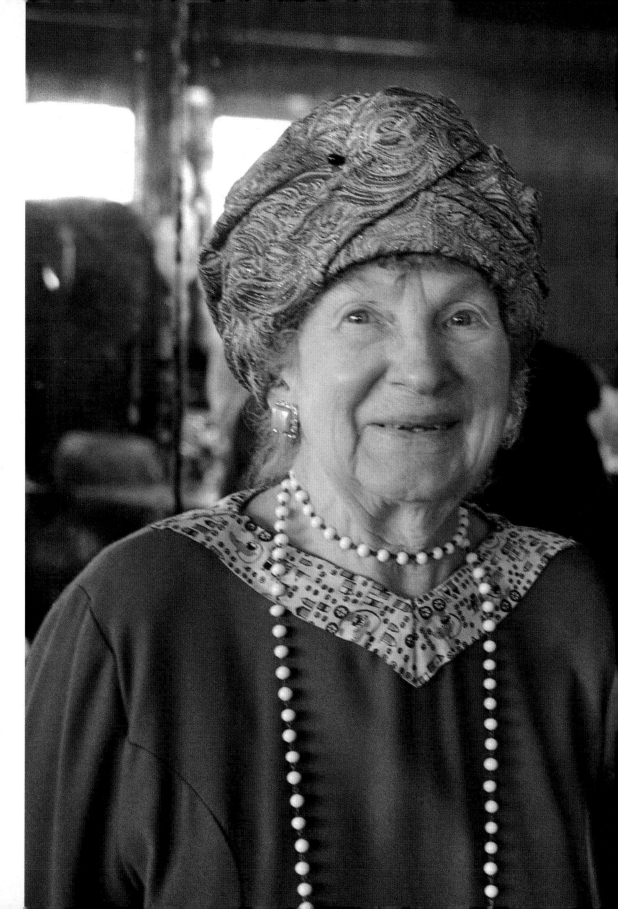

Sunday afternoon, sisters with handmade hats, 1977

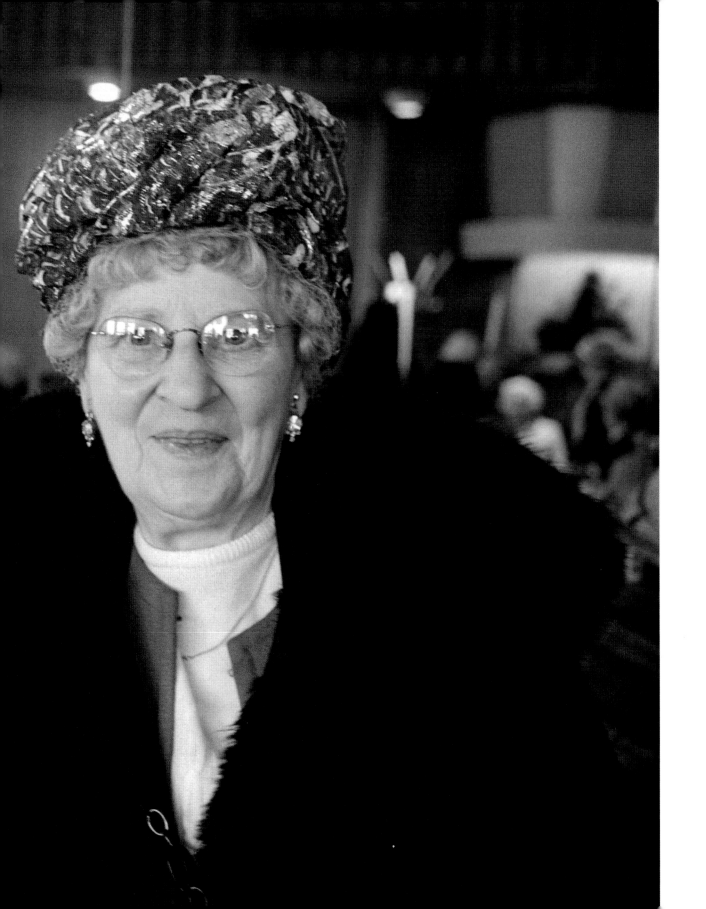

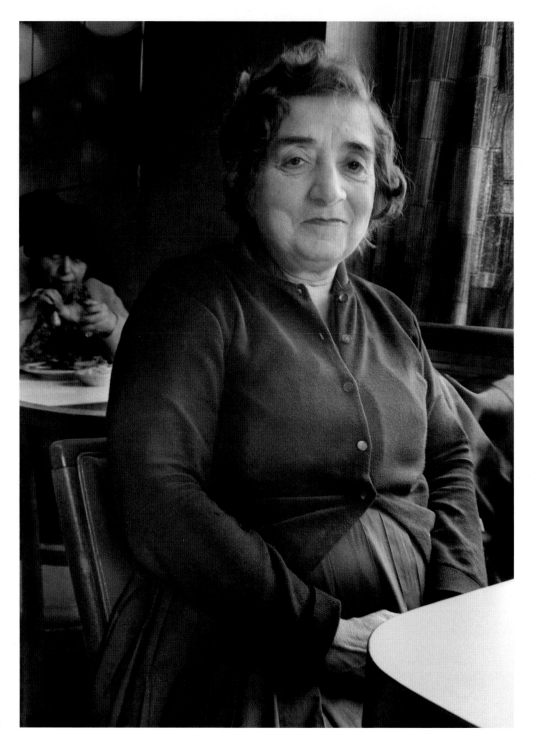

Woman, 1975

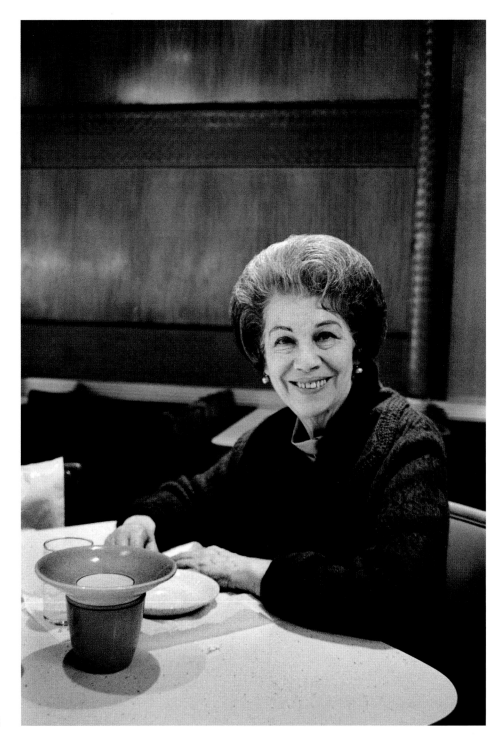

Woman, 1976

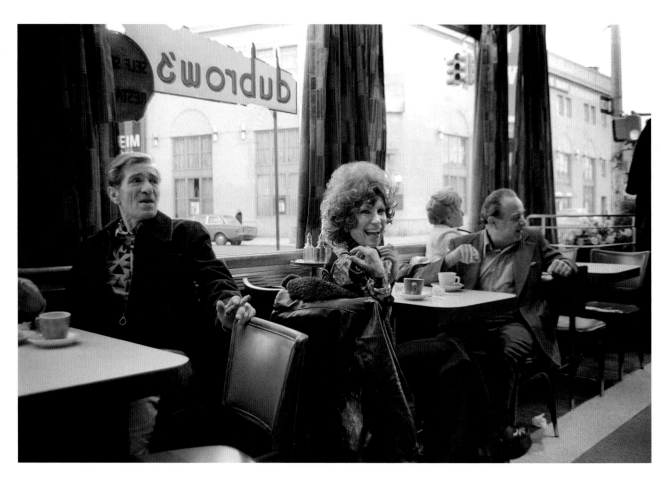

Mary in the afternoon, 1975

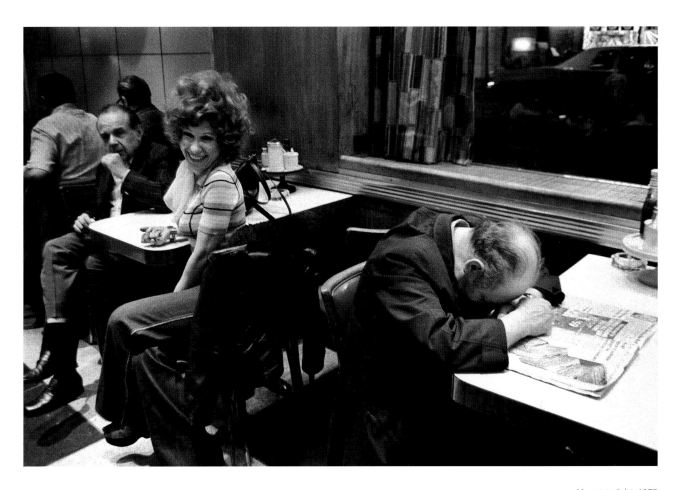

Mary at night, 1975

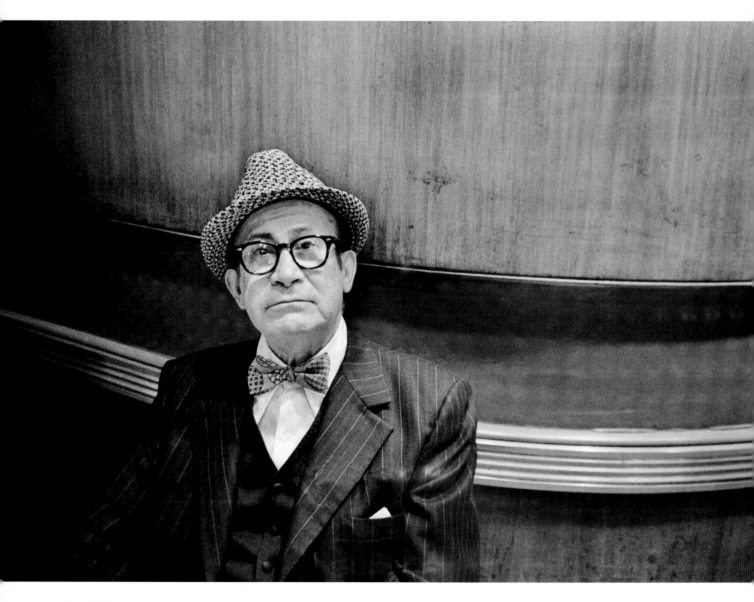

Man with bowtie, 1976

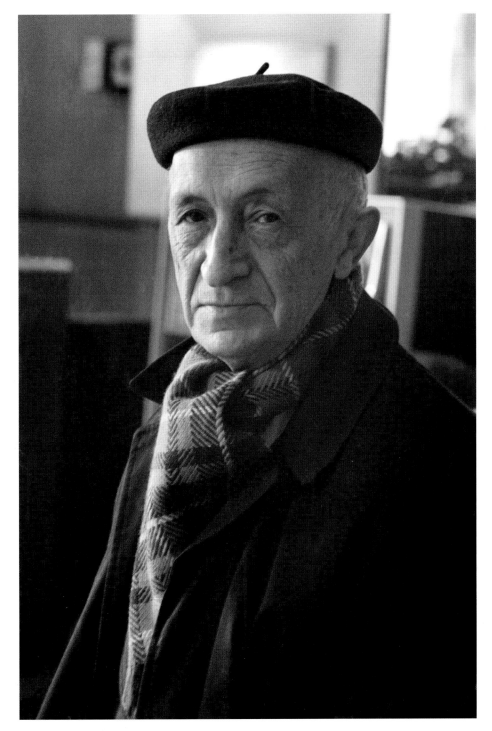

Julius, 1975

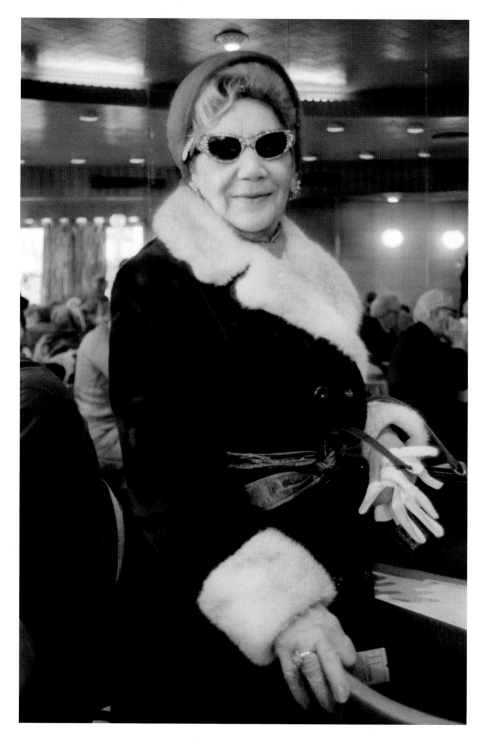

Woman in sunglasses,
1975

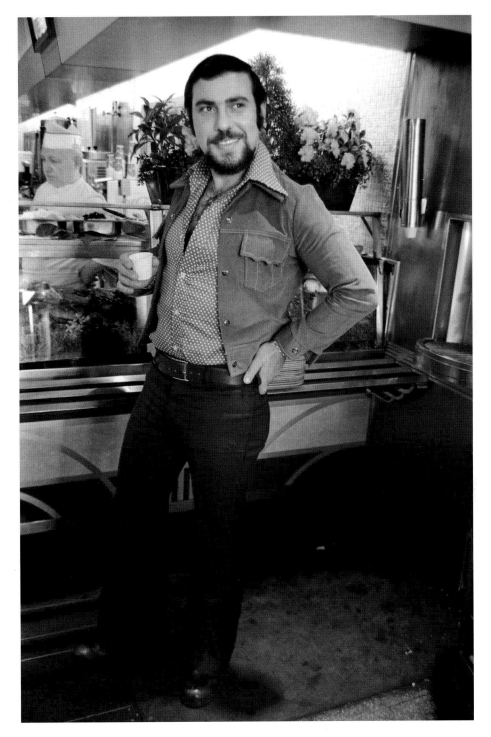

Israeli man, 1975

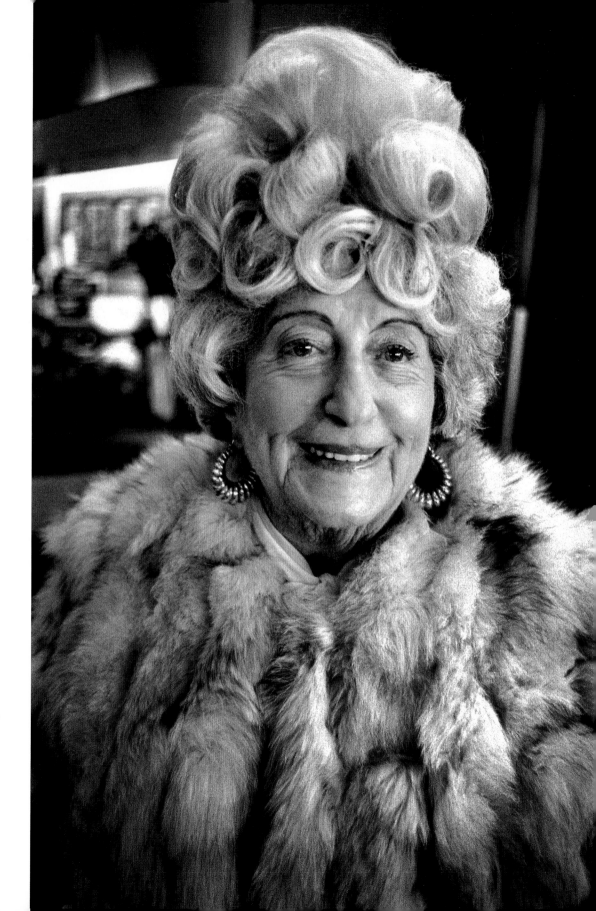

Rose celebrating her
eightieth birthday,
1977

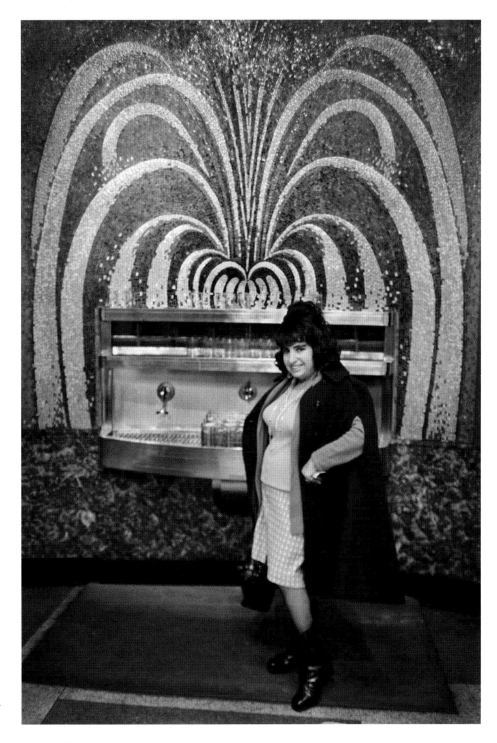

Woman posing at water
fountain, 1977

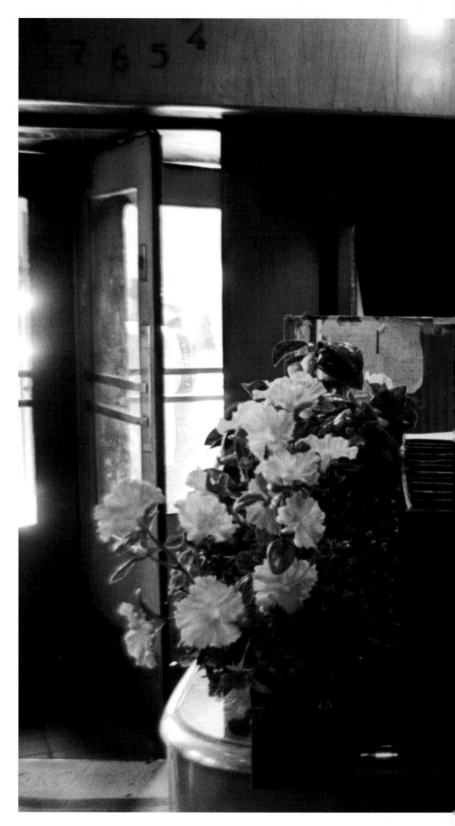

Roz, the cashier,
1975

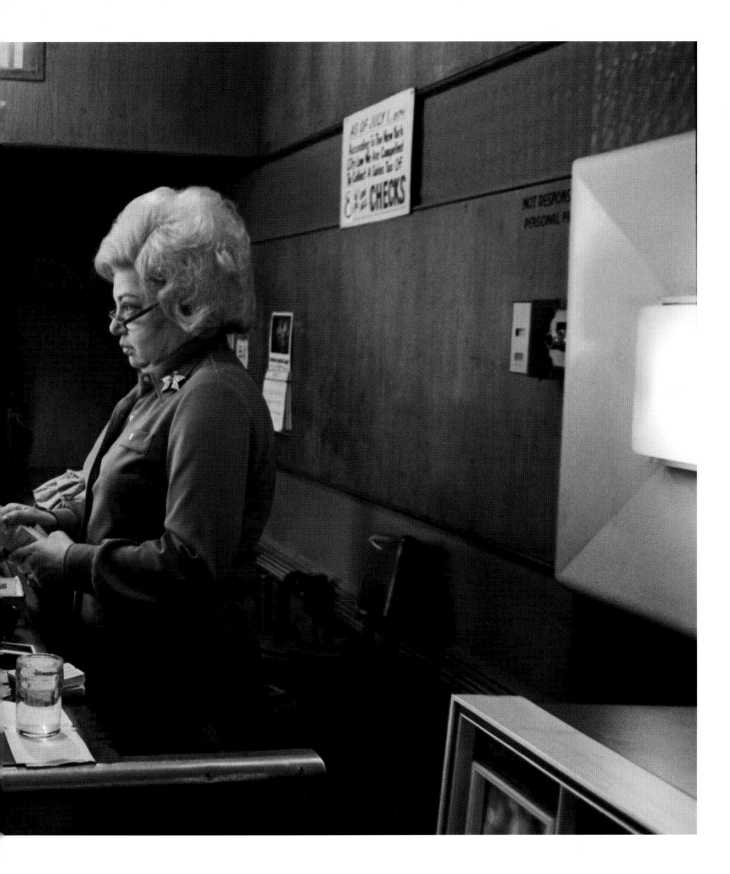

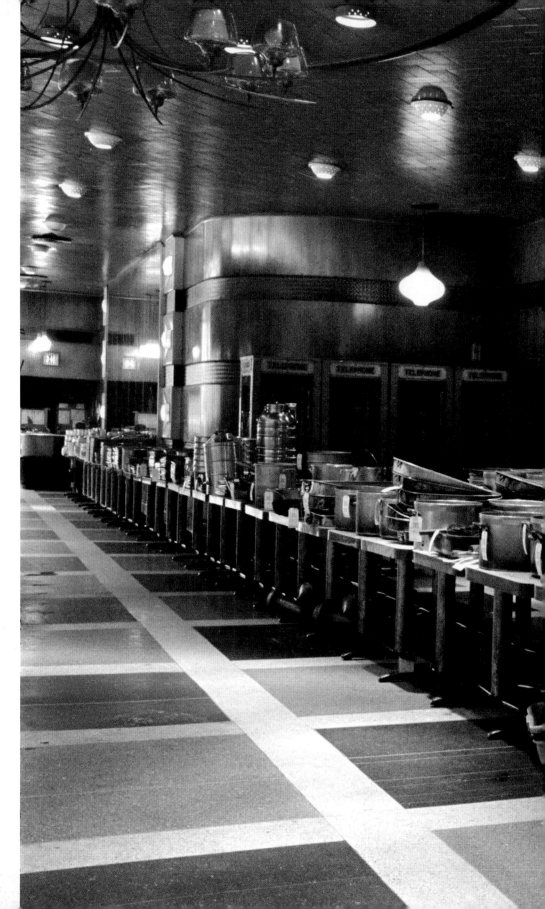

Auction of the pots, 1978

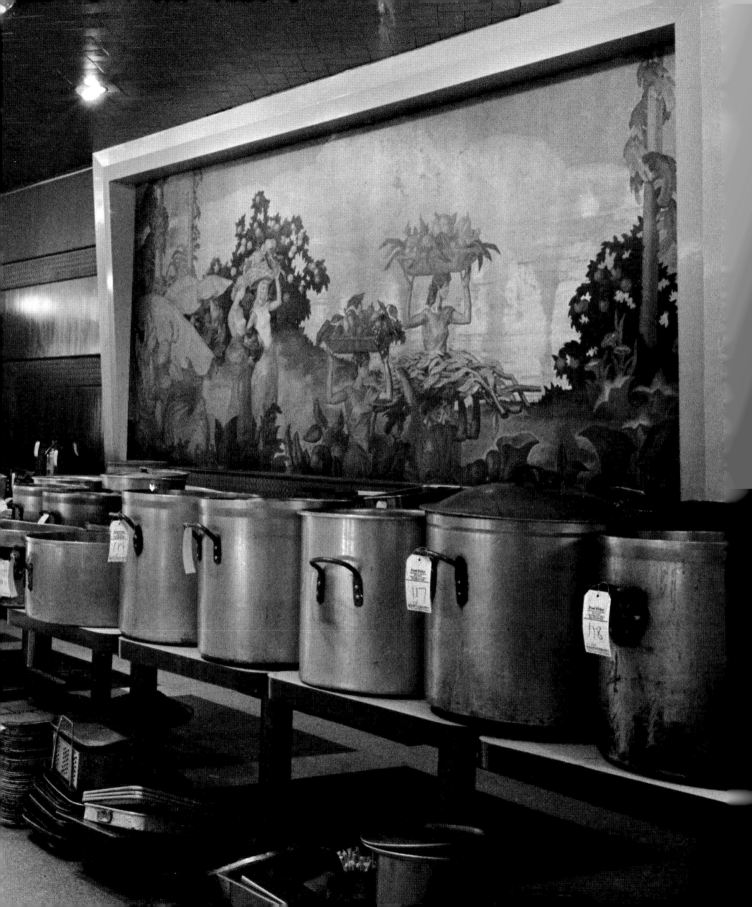

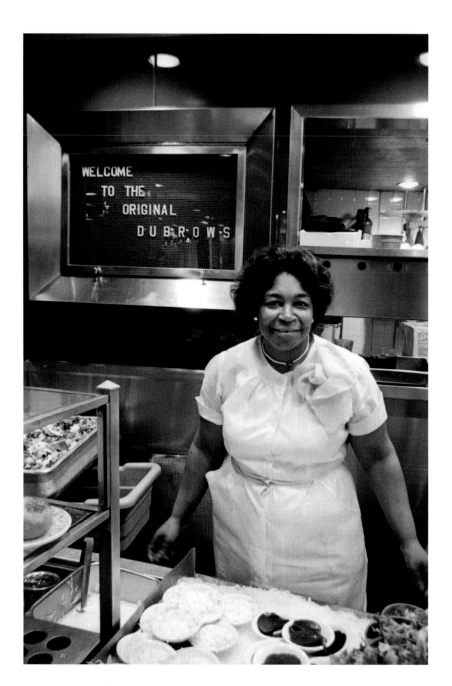

Counterwoman, Dubrow's, Garment District, 1976

dubrow's, garment district, manhattan

The Epicenter of the Schmatta Business

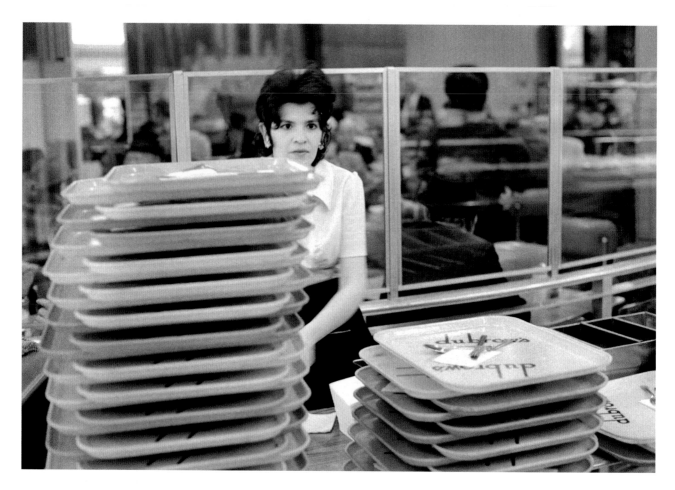

Preparing for lunch hour, 1976

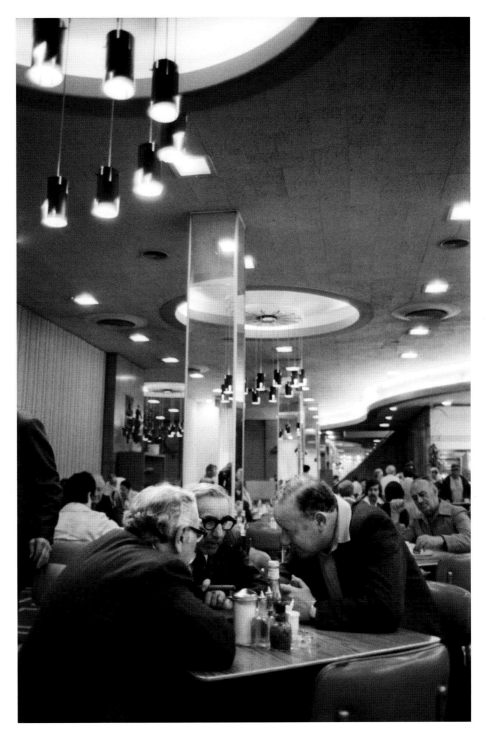

Making a deal,
1976

123

The pinnacle of Dubrow's, the pinnacle of food, perhaps the pinnacle of life itself, were the Kaiser rolls. . . . Hard like peanut brittle on the outside, and soft and warm and chewy on the inside. Warm, they were, and with the sweet butter inside, they were pure ambrosia.

—Uncle Slappy via George Tannenbaum, Ad Aged blog

Kaiser rolls, closing night, 1985

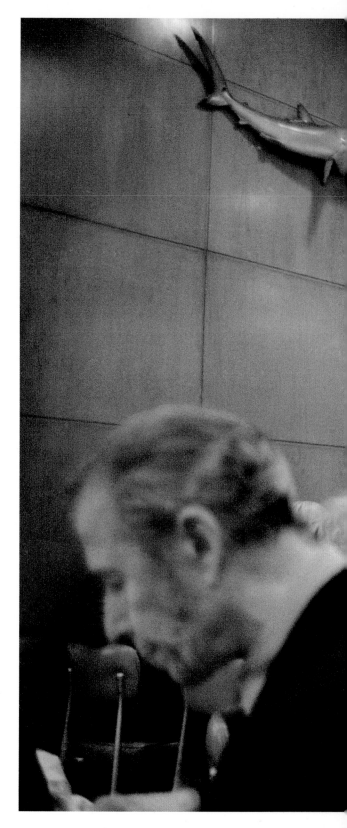

Lunchtime, 1975

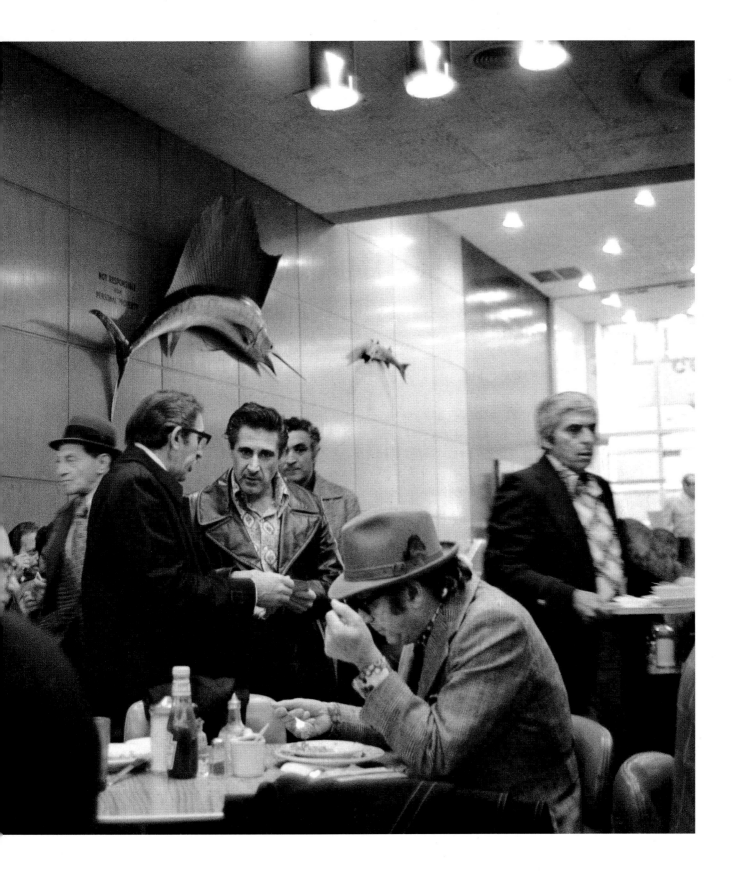

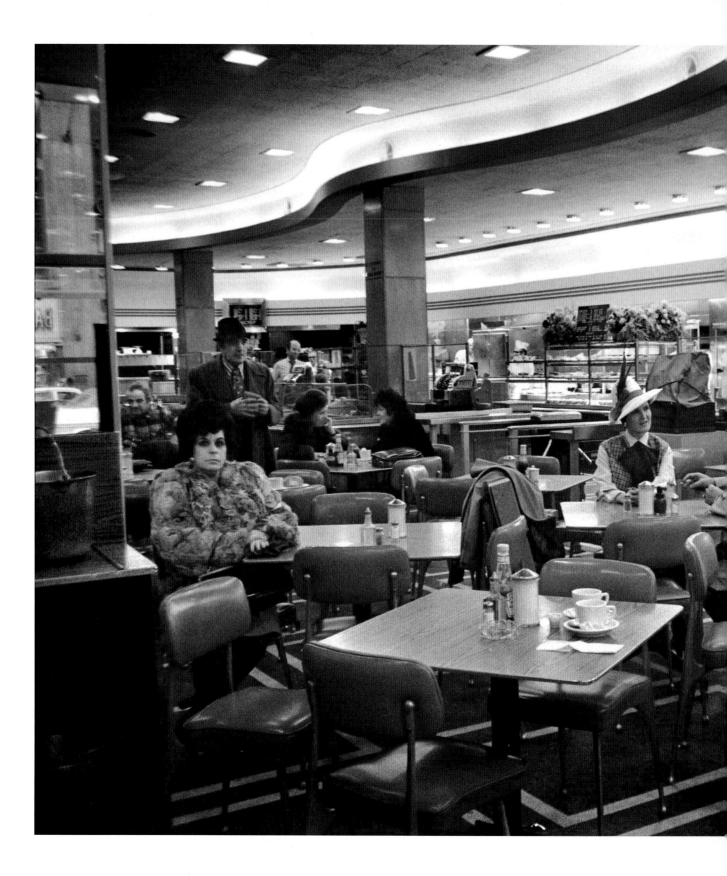

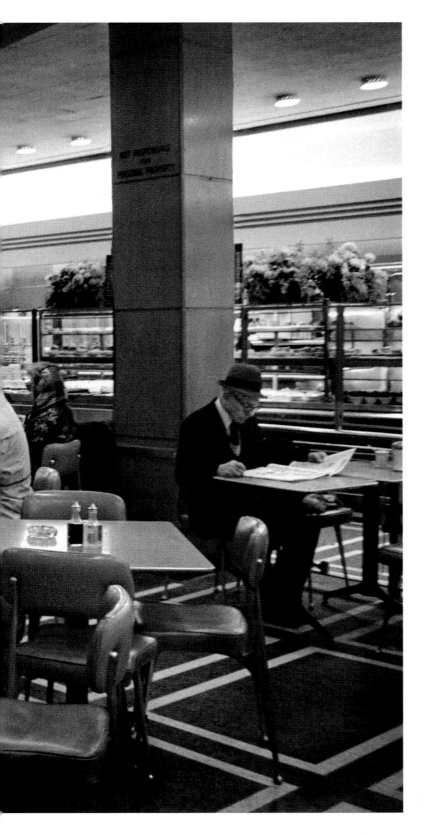

Midcentury modern "gazelle"
chairs designed by Shelby
Williams, 1975

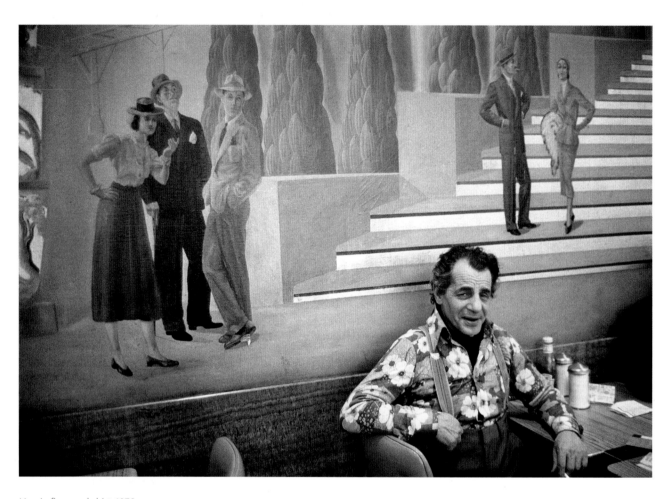

Man in flowered shirt, 1976

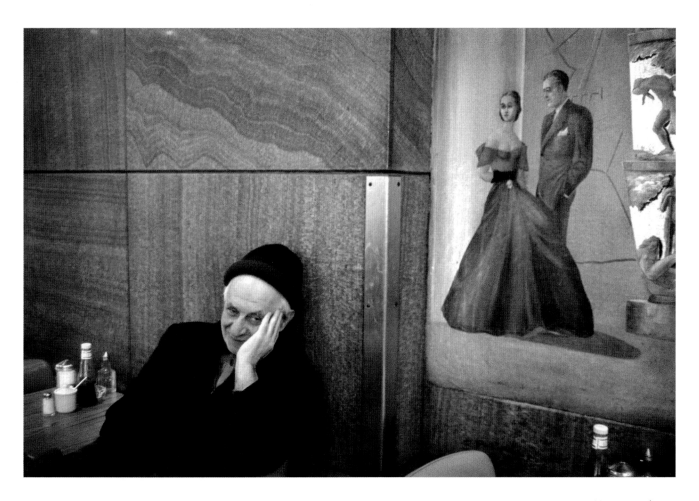

Man at mural, 1976

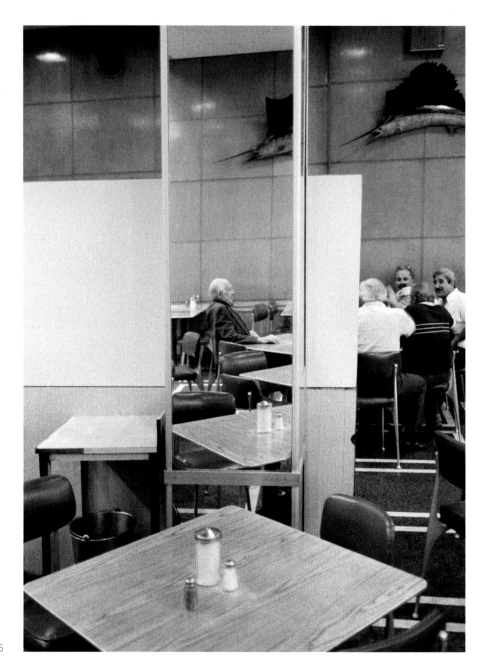

Reflection, 1985

132

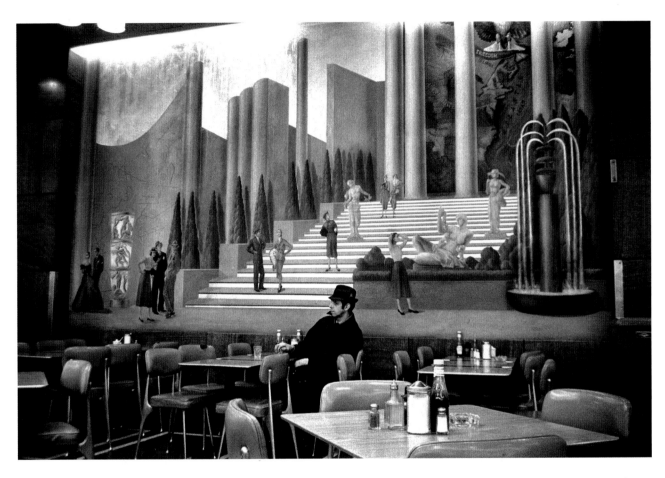

Man at mural, 1975

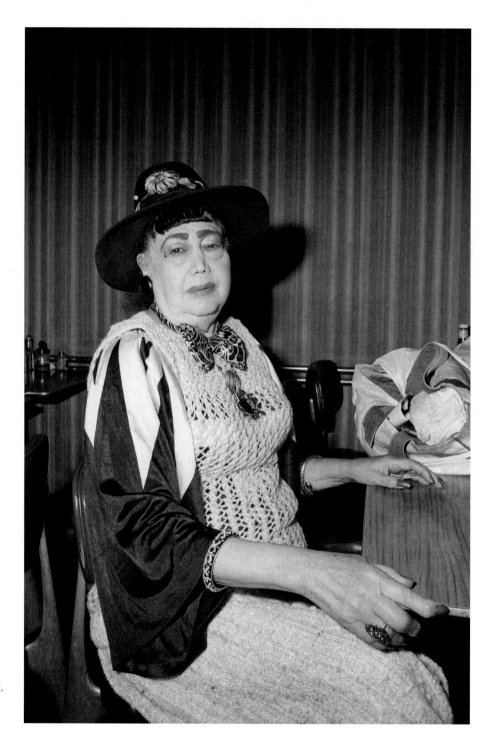

Elaine, closing night,
Dubrow's, Garment
District, 1985

134

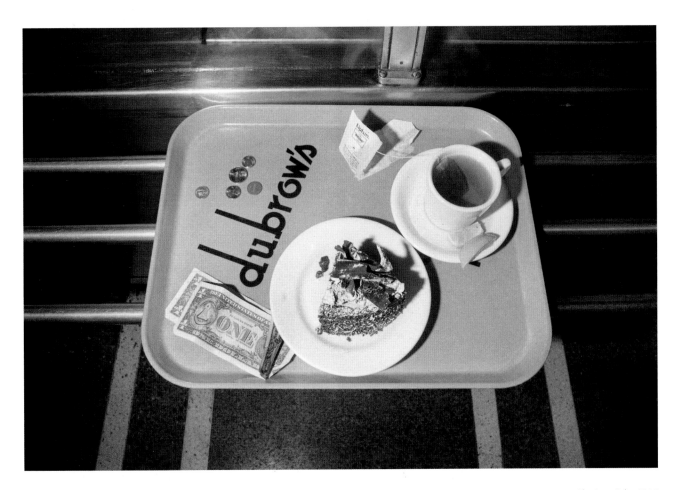

Closing night, 1985

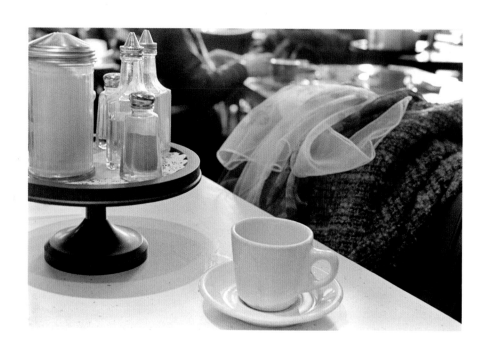

acknowledgments

I begin by going back to my teenage years and thanking the Madison High School boosters for rejecting me. While I missed the opportunity to shake pompoms at football games, I instead spent Saturday mornings studying and making art at the Brooklyn Museum junior membership classes, an education that set a lifelong path.

The inspiration from my early teachers and supporters—Barney Cole, Walter Rosenblum, Paul Sheridan, Larry Siegel, Lisette Model—motivated me to photograph the changing city of the 1970s.

For almost fifty years these photographs have rarely been seen. My sincere gratitude to Marissa Scheinfeld for her advice and for generously sharing how to format a book proposal. I never could have surmounted the first hurdles without you.

Grateful acknowledgement to the many people at Cornell University Press who were so instrumental in making this project a reality, especially Michael McGandy, senior editor and the editorial director of Three Hills, for listening and allowing me to trust my instincts. Michael was patiently instrumental in setting the original guardrails when my ideas veered all over and in helping to cement a viable concept. Many thank yous for the professionalism of the Three Hills team: Clare Jones, Karen Hwa, and the patient designers..

I have tremendous appreciation for the zesty and meaningful introductory essays which two formidable writers, Deborah Dash Moore and Donald Margulies, made time to write.

My acknowledgment to the Dubrow family descendants for allowing me into their legacy, in particular, Eve Lyons for keeping a light on at her Dubrow's Cafeteria blog.

An important role was been played by my sister, Pamela Gilden, by not accidentally turning on a light while I huddled in our dark bedroom loading film in the 1970s and by seeing me through the photograph selection and sequencing during the pandemic.

Thank you to my wonderful daughter, Adina, and gratitude to my husband, Mark, for always being on point with his criticisms and chasing me out of rabbit holes to keep the important tasks front and center.

To everyone who generously shared memories, images, and stories—a sincere thank you. And viewer, I appreciate your taking the time to look at these photographs. I hope to hear many more stories of how Dubrow's impacted your life and how places of gathering are central to the social experience.

biographies

Marcia Bricker Halperin is a lifelong Brooklynite originally from Flatbush. She began photographing while an art major at Brooklyn College and became convinced that she wanted to seriously pursue photography after studying there with Barney Cole and Walter Rosenblum. She received a master of fine arts degree from Brooklyn College in 1977 and subsequently had her first solo exhibition at the Midtown Y Gallery. In the late 1970s she was active with the Photographers Forum, an organization of documentary photographers that was a continuation of the 1940s Photo League and reflected the same humanistic and aesthetic concerns.

From 1978 to 1980 she was employed by the CETA Artists Project under the auspices of the Cultural Council Foundation. As a member of the documentation team she was given assignments that included photographing early Soviet refugees and their introduction to American culture in Brighton Beach and housing issues in Hell's Kitchen.

She spent thirty-five years in K-12 education teaching art and photography and using her creativity in special education with disabled and autistic students. Her photography has been included in many group exhibitions, including at the Brooklyn Museum and the International Center of Photography. Her work is represented in a number of collections.

Donald Margulies is an American playwright and adjunct professor of English and Theater Studies at Yale University. He won the 2000 Pulitzer Prize for Drama for *Dinner with Friends* and was a finalist twice before for *Sight Unseen* and *Collected Stories*. His many other plays, including *Long Lost, The Country House, Shipwrecked! An Entertainment, Brooklyn Boy*, the Tony Award–nominated *Time Stands Still*, and the Obie Award–winning *Model Apartment*, have been produced on and off-Broadway and in theaters across the United States and around the world. He has received grants from the National Endowment for the Arts, the New York Foundation for the Arts, and the John Simon Guggenheim Memorial Foundation, and was the recipient of the 2000 Sidney Kingsley Award for Outstanding Achievement in the Theatre by a play-wright. In 2005 he was honored by the American Academy of Arts and Letters with an Award in Literature and by the National Foundation for Jewish Culture with its Award in Literary Arts.

In 2019, Margulies was inducted into the American Academy of Arts and Sciences. He has developed numerous screenplays, teleplays, and pilots for HBO, Showtime, NBC, CBS, Warner Bros., TriStar, Universal, Paramount, and MGM. The film of his screenplay, *The End of the Tour*, which premiered at the Sundance Film Festival in 2015, was nominated for the Film Independent Spirit Award and the UCLA Scripter Award for Best Screenplay.

Deborah Dash Moore has been a pivotal figure in the emergence and advancement of the field of American Jewish history since the last quarter of the twentieth century. She is the Frederick G.L. Huetwell Professor of History and professor of Judaic Studies at the University of Michigan. Her research interests include American Jewish history, twentieth-century urbanization, and documentary photography. She received her PhD from Columbia University.

She has also engaged in a number of major editorial projects, including the three-volume, award-winning *City of Promises* (2012, New York University Press) and is currently serving as editor-in-chief of the ten-volume anthology, *The Posen Library of Jewish Culture and Civilization*.

Moore's scholarly interests reveal an ongoing concern with both urban and visual culture. In 2001, she coauthored *Cityscapes: A History of New York in Images*, which traced the city's history through images—a book that in many ways planted the seeds for her future research interests in both photography and urban culture.

Her current research project focuses on the work of mid-twentieth-century New York Jewish photographers. Rather than considering how Jews have been represented in visual images, Moore's work shifts the focus to the ways Jewish photographers crafted their own vision of the city from behind the camera. Her book *Walkers in the City: Jewish Street Photographers of Midcentury New York* will be published in fall 2023.

The cafeteria as an institution is gone—the Automat, the Waldorf
(long the center of Village indecorum and the midnight arts),
Bickford's—and I miss them all, but none more than Dubrow's—
an agora it provided, as well as decent food, bright lights, and
tolerant of long sieges of babbling intellectuals at the pale tables.

—Robert Kelly, "City as Pilgrimage"

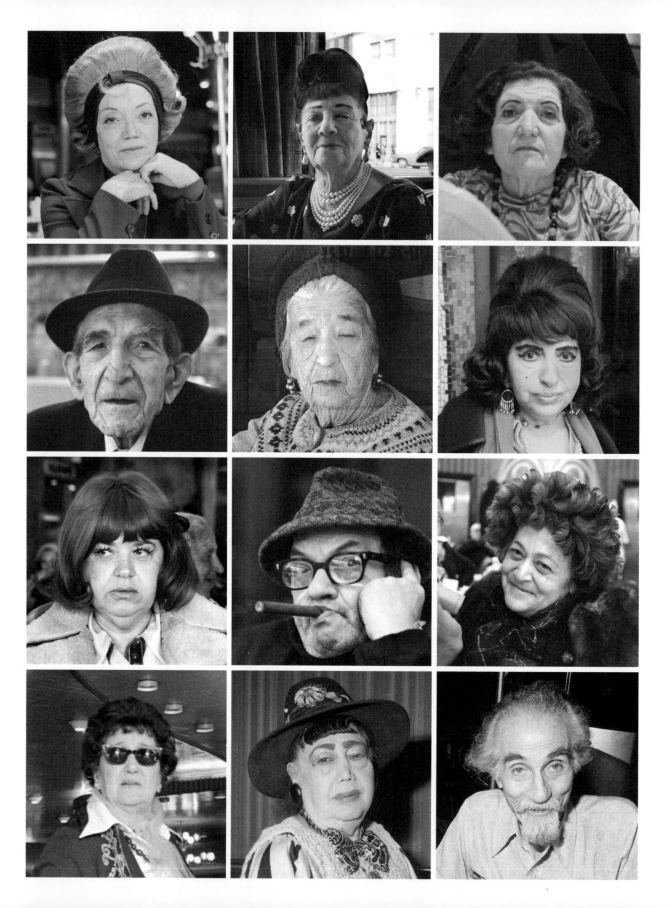